The Watercolour Answer Book

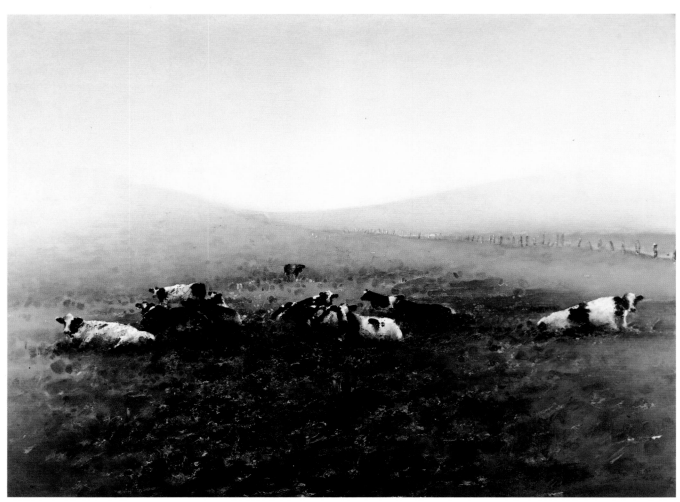

WONDER
Watercolor on 300-lb. (640gsm) Lana hot-pressed paper
21″×29″ (53.3cm×73.7cm)
Private collection
Photo by Ron Zak

The Watercolour Answer Book

Catherine Anderson

Search Press

About the Author

A painter for over thirty years, Catherine Anderson was born in Chicago and attended the American Academy of Art, University of Cincinnati and Academy of Art College in San Francisco. She now teaches at her Napa Valley Studio in the Vineyards and has received numerous awards from top art organizations in the United States. She is a signature member of the National Watercolor Society, California Watercolor Society and Knickerbocker Artists. She has been in both the prestigious Denver Rotary Club's "Artists of America" exhibit and the "Great American Artists" exhibit in Cincinnati, Ohio, since 1996. Her work appears in the North Light books *Splash 5*; *Make Your Watercolors Look Professional*; *Exploring Color*, revised edition; and *The Best of Flower Painting*. It also appears in *The Best of Watercolor 2: Painting Texture*, *The Artist's Magazine* and *Southwest Art* magazine, as well as on the cover of San Francisco's famous Greens Restaurant cookbook *Fields of Greens*. She has been writing a column called "Water Rescue" for the magazine *Watercolor Magic* since 1995, and she is listed in *Who's Who of American Women* and *Who's Who in America*. Her paintings are on display across the United States in museums, galleries and private collections.

First published in Great Britain as *The Watercolour Answer Book* in 2000 by
Search Press Limited
Wellwood, North Farm Road,
Tunbridge Wells, Kent TN2 3DR

Originally published in the USA as *Basic Watercolor Answer Book* in 1999 by
North Light Books, an imprint of F&W Publications, Inc.
1507 Dana Avenue, Cincinnati, Ohio 45207, USA

Edited by Pamela Seyring
Production edited by Marilyn Daiker
Designed by Candace Haught

ISBN 0 85532 855 X (HB)
ISBN 0 85532 856 8 (PB)

If you experience difficulty in obtaining any of the materials mentioned in this book, then please write to Search Press Limited at the address above, for a current list of stockists, which includes firms who operate a mail-order service.

The permissions on page 123 constitute an extension of this copyright page.

Acknowledgments

Much appreciation to everyone who contributed to and helped me write this book. It is truly a miracle.

I would like to thank Pamela Seyring, my editor. She gave me guidance and support throughout the process of writing this book. I would also like to thank production editor Marilyn Daiker and designer Candace Haught. Special thanks to the artists who contributed their art and comments to this book. Very special thanks to my photographers, Jerry Mennenga, who shot artwork for the book and pitched in his much-appreciated creative ideas, and Ron Zak, whom I have been working with for years. Thank you to computer whizzes Diane Farrar and Jerry Mills (my cousin who, over the phone [all the way from Marquette, Michigan], got my book out of the garbage when I accidentally dumped it—what a guy!).

Thank you to Tim Hopper and Jana Cernikovsky at HK Holbein for their generous support, kindness, assistance, outstanding paints and superior large wash brushes from Japan. For assistance, information and supply of different Fabriano papers used in the book, thank you to Pierre Yann Guidetti, Hilary Mosberg and Michael Ahearn at Savoir Faire, importers of Lascaux Aquacryl. I am particularly grateful to Michael for taking the time to answer the many, many questions I had about materials. Thank you to M. Graham & Co. for its fine acrylic and watercolor paints.

Thank you to my many teachers. Thelma Cornell Spain taught me not to be afraid. Bonnie Casey taught me about feeling in a painting. Mayumi Oda showed me discipline, commitment and that I could earn a living doing what I love. Thank you to my student Mary, who answered my question, "What is art all about anyway?" And to all the many, many, many mistakes I have made and learned from.

Thank you to my neighbors and friends who put food in my mailbox fresh from their gardens. Thank you to my dogs, Yuki and Rusty, for their patience waiting for walks; and cats Peetie, Neko and Mr. Studley, who waited a little longer for their supper sometimes.

Last but not least, I'd like to thank Anthony Horne, who ran my errands and responded to my calls on his pager by bringing me kitty litter, milk and chocolate on his way up the mountain. You name it, he brought it. He has truly been a tremendous help to me over the years I've lived high above the Napa Valley (miles from nowhere). I do not know what I would have done without him, especially while writing this book.

Dedication

To Papa for opening my eyes

to the love and joy of art,

and to my mother and father

for their love and support,

helping me find the skills

to share it.

This book is dedicated

to all artists.

May we always have

"beginner's mind." Always.

On Table of Contents, pages 6-7

GOD'S GOLDEN ESSENCE
Watercolor on 300-lb. (640gsm)
Lana hot-pressed paper
21" × 29" (53.3cm × 73.7cm)
Private collection
Photo by Ron Zak

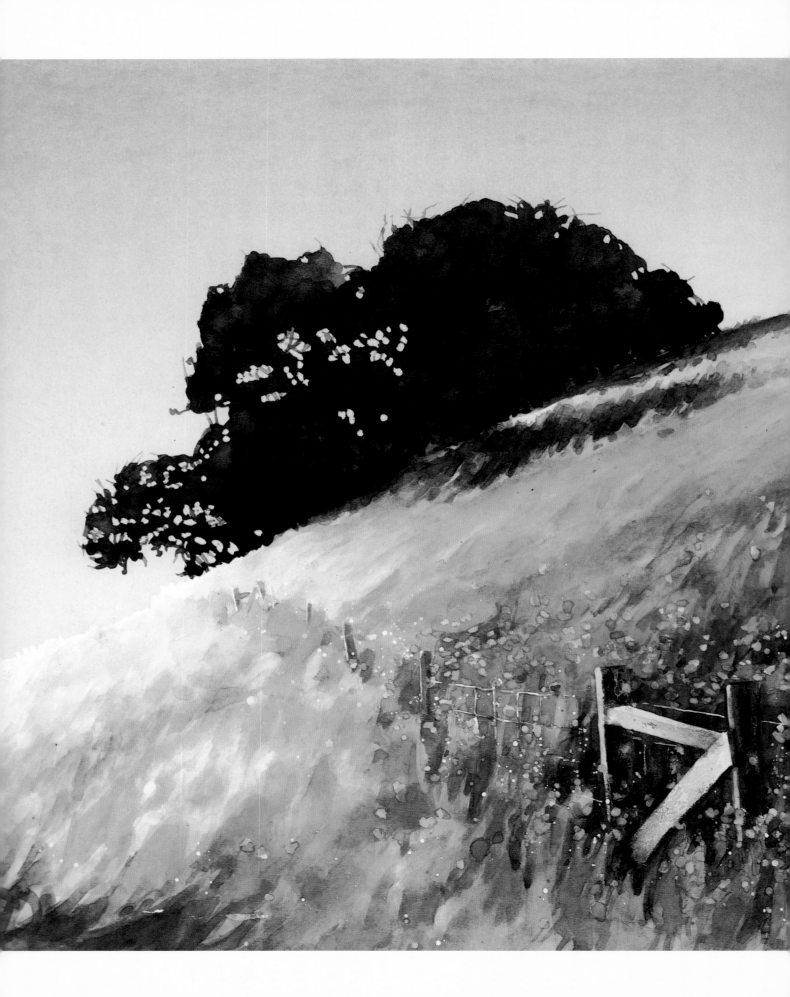

Table of Contents

CARTOON
Len Clark
Watercolor and ink on 140-lb. (300gsm) hot-pressed paper, 6" × 8" (15.2cm × 20.3cm)
Collection of the author
Photo by Jerry Mennenga

The Most Valuable Lesson You Can Learn

I wanted to open my book with a story that has a powerful lesson as essential to understand and practice as the questions and answers in this book—if not more essential. You can read this book and a hundred other books and learn a great deal about watercolor. If you keep the knowledge in your head and never apply it because you are afraid to make a mistake, take a risk, take action and confront your inner critics, you will never paint.

The Story Goes Like This . . .

Mary, a beginner in my evening watercolor class, was a poet. She was exceptionally knowledgeable about the arts and an extremely interesting person whom I enjoyed having in class. She painted exactly what she wanted and rarely used a photograph for reference. I often wondered what went through her mind while she was painting these fascinating paintings; they looked kind of like folk art.

Then one day I won an award in the American Watercolor Society's annual exhibit. A friend and I decided to fly to New York City to attend the awards dinner to receive my award. It thrilled us to see the show, and we were ecstatic about being in New York. We took in as many of the galleries and art museums we possibly could, soaking in all the art. It was a stimulating and rejuvenating trip for both of us.

In my first evening class after our return, Mary handed me a small painting. It was a beautiful landscape of what looked like a little pond, and she said to me with great pride, "Look what I did while you were gone!" It was like nothing she had ever painted before. I praised her on what a wonderful job she did and told her how proud I was of her. I thought the painting was a done deal—finished. Obviously, Mary did not think so. "I wanted to ask your opinion on something first before I did it. I was thinking about putting a whale in the middle of the pond. What do you think?"

Speechless, it took me a moment before I could respond. "God, help me come up with something," I prayed. I thought of all the art I had seen in the New York museums—old mattresses hanging from the ceiling and wrapped in bungee cords, a black hearse covered with tar and all sorts of objects stuck to it at the Whitney Museum of American Art, the Metropolitan Museum of Art, the Guggenheim, the Museum of Modern Art.

God knows how much time I took to respond, but the question that came to me was, "What is art all about anyway?" I realized, at that moment, that there really are no rules. Critiquing Mary's work would have stopped the creative process of expressing what she wanted to express. Who am I to tell anyone what or how she should express anything? It was her painting, and I handed it back to her. "Mary, put the whale in!"

There are no real rules or formulas (however, I do help my students who want rules, so don't worry). I didn't care if Mary wanted to put Big Bird in the middle of the pond. She had the guts and confidence to express herself. She put the whale in. Mary had no rules.

I have told that story to my other classes and workshops—and it has stuck. I have heard them shouting across the room, "Oh, put the whale in!" And some of the students have painted whale paintings.

Introduction

The Lesson Is . . .

Are you having a problem taking a risk because you are afraid of making a mistake? Do you hear that voice saying to you, "I wonder what would happen if?" Go ahead.

PUT THE WHALE IN!

Winds of Change
Watercolor on 300-lb. (640gsm) Lana hot-pressed paper
21" × 29" (53.3cm × 73.7cm)
Private collection, Photo by Ron Zak

"And the day came when the risk to remain tight in a bud was more painful than the risk it took to blossom."

—Anaïs Nin

(American author, 1903-1977)

SURPRISES AND CHALLENGES

I began painting in oils and decided to take a watercolor class just for fun. Well, that was all she wrote. It was love at first sight. Watercolor was full of surprises! The medium intrigued me to no end. To this day that same feeling is still with me. Every time I paint, I discover more surprises and challenges.

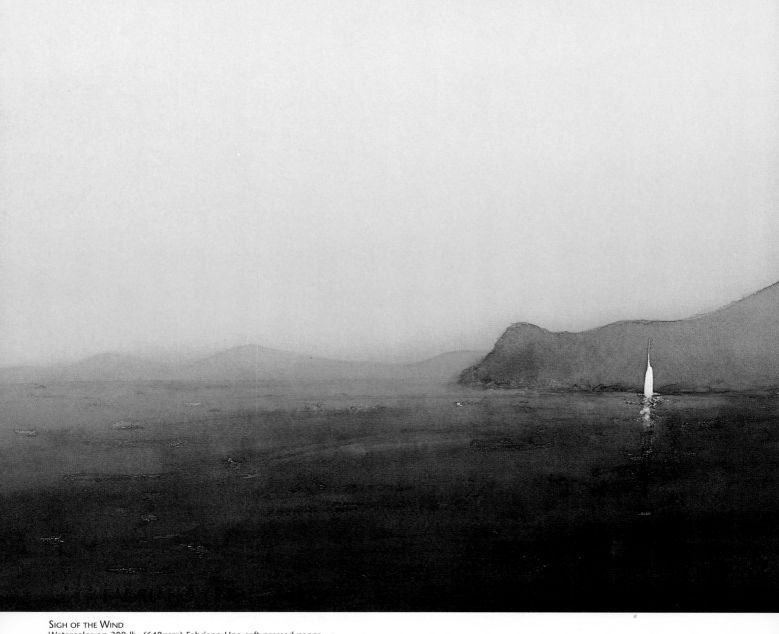

SIGH OF THE WIND
Watercolor on 300-lb. (640gsm) Fabriano Uno soft-pressed paper
27″×29″ (53.3cm×73.7cm)
Private collection
Photo by Ron Zak

Paper and Painting Surfaces

It's appropriate that this chapter is the first, because I believe that your watercolor paper is your most important supply. There are all sorts of surfaces to paint on, but in this chapter I will be addressing only commonly used watercolor paper.

I learned the importance of paper from my first and only watercolor instructor, Thelma Cornell Spain, who made our class buy heavy 300-lb. (640gsm) paper, 100 percent rag (the percentage of cotton fiber in the paper). When we whined about its price, she always responded with, "What if you painted your masterpiece and it was on cheap paper?" Well, that got me thinking about that possibility. From that day on, I have painted on the best paper; there is nothing like it. Not every piece will be a masterpiece, but when that certain painting "hits," it will be on the best watercolor paper.

The good 100 percent cotton paper will last longer when the masterpiece appears, but that is not the only advantage to using it. When I started teaching, I began to see the struggle students were having with their watercolor papers. Some students bought the best paper; some didn't. Those students that didn't pay the extra money for the good paper or couldn't afford it were the ones who suffered the most. Since I never had to struggle with my paper, I was not aware up until then of the nightmare different watercolor papers could be.

Watercolor is a difficult medium to begin with, so why make it harder on yourself? Do not cut corners by buying a less-expensive paper. It's difficult to move on, to continue to grow and learn, when you are constantly fighting with your paper—you can become very discouraged. Get the best watercolor paper from the start.

I really understood the importance of my watercolor paper not long ago, when I was painting for my biggest gallery show ever. The paintings were almost complete when black spots began appearing across the top of all the paintings, through the painted side of the paper! I had obviously gotten a bad batch of paper, but fortunately the paper distributor was not far away. I phoned the company with my sad story and the distributor sent a new batch. I spent days drawing new paintings on the new paper, but it did not take the paint evenly when I put my first wash on it. Definitely a sizing (see page 17) problem. The distributor sent more paper, but time was running out and I had no time to deal with another bad batch. What were the odds of getting three bad batches in a row? I could not switch brands now. This was my paper that I had come to know and love, the paper I had been using for years. I had to go for it. The third batch they shipped was fine, and I ended up rescuing some of the paintings with the mold by cropping about 4 inches (10.2cm) off the top.

Your paper is everything. If you run out of your favorite tube of paint, you can get away with a substitute color or you can mix one. If you lose your favorite sable brush, you can always substitute another one. You cannot skimp on your paper. It is critical.

Explore different papers and paper surfaces. There are so many. Sometimes I will just sit and read art catalogs. If I see a paper that interests me, I will order it. You can really learn a great deal when you experiment with new watercolor papers.

THERE'S A REASON

When something doesn't turn out the way you want, instead of getting upset, know that there is a reason for it.

What surface and weight of watercolor paper would you recommend for a beginner?

Begin with a sheet of 140-lb. (300gsm) cold-pressed paper and see how you like it. If you use a lot of water when you paint, you will want to move on to a heavier, 300-lb. (640gsm) cold-pressed paper that will not buckle as much (see page 13).

I am new to watercolor. I want to practice on something, but I do not want to spend a fortune on paper. What do you suggest?

If this is for practicing techniques only, I would suggest a *pad* of 140-lb. (300gsm) cold-pressed watercolor paper. Get the best you can afford. Pads are for your exercises, not for final paintings, so they are what you should use for this purpose. You will notice quite a difference between a watercolor pad and a quality watercolor paper.

Can you explain the different paper surfaces?

Here I have painted on three different surfaces to show you how the paint reacts on each one. These three are the most commonly used surfaces: rough, cold-pressed and hot-pressed. Fabriano Uno has a delightful new surface, called soft-pressed, that has a velvety feel to it. It does not look handmade, but don't let that fool you. It is a texture in between a smooth surface (hot-pressed) and a slightly textured surface (cold-pressed). You get the best of both worlds. I did *Sigh of the Wind* (pages 10-11) on Fabriano Uno soft-pressed.

ROUGH

Rough paper has more texture than others and seems to soak up paint more, leaving the color on the light side. No big deal. Just adjust your amount of paint to make the color the way you want it. You will get to know your paper after a while—and how much paint it will take.

COLD-PRESSED

This is a little smoother than the rough, but with a bit of texture to it. Cold-pressed 140-lb. (300gsm) paper is the most commonly used among watercolor artists. The paper does not absorb the colors as much as other papers, making the colors brighter.

HOT-PRESSED

Think of smooth, slick hot-pressed paper as if you had ironed out all the texture. Paint sits on top of this surface and makes interesting puddles when left to dry naturally. I would not recommend this to a beginner as it is difficult to control paint on this surface.

What does the weight of the paper mean?
It is what a ream of paper weighs. For example, five hundred sheets of heavy 22″×30″ (55.9cm×76.2cm) paper may weigh 300 pounds (136.2kg). The higher the weight, the heavier the paper and the higher the price (but worth it).

My paper buckles while I am painting on it. What should I do?
Buy the heavier 300-lb. (640gsm) paper, which will not buckle as much as 140-lb. (300gsm), or lighter, paper. Another possibility would be to stretch your paper (see page 14).

Heavier papers are wonderful if you use lots of water when you paint. The more water you use, the more your paper is going to buckle, but it will buckle less with heavier paper.

If your paper buckles while you are painting, let it dry. Work on something else. When your painting is dry, press it overnight by putting a piece of tissue paper over it and then some heavy books. Work on it again in the morning. Eventually you will find out which paper is comfortable for you.

How do I store my watercolor paper, both before I use it and after I paint on it?
Store it flat. If I have a package of twenty-five sheets shipped to me, I usually store the paper flat in the original box and wrapping. I also have a rack for storing paper. Wrap your paper in something protective, because all sorts of things can ruin it if it's left exposed. Do not set anything heavy on it that would cause it to crease or become embossed, and the same goes for stacking something on top of it. For example, a piece of illustration board smaller than your paper with enough weight on it can crease your paper, and a spiral pad can scratch the surface; so be careful. When I have finished a painting and it's dry, I cover it with tissue paper and store it flat in my portfolio, in a cool area until it goes to the framer.

If you buy only a few pieces of paper at a time, store them in portfolios. Portfolios are also great for transporting your paintings.

What does "acid free" mean?
It means that your paper has a relatively neutral pH of about seven; numbers higher than seven are more alkaline, while those lower than seven are more acid. A paper with a neutral pH is most desirable because it will not yellow over an extended period of time. Low-quality papers with a high acid content discolor rapidly. If your paper is not acid free, it will not have a very long life. Papers that turn brittle and yellow quickly, such as newspapers, have a lot of acid in them. That's why you should get an acid-free mat and backing when you get your painting matted. These materials do not eat your masterpiece when they are touching each other in the frame.

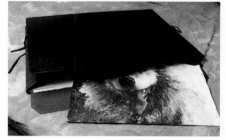

STORING AND TRANSPORTING SINGLE SHEETS OF WATERCOLOR PAPER
This is a black vinyl portfolio I use to store and transport single sheets of watercolor paper. You need something sturdy that will protect your paper and not crease it. At home, I store the portfolio flat. It has strong ties on all three sides and flaps to protect artwork. You can tuck your full-size sheets under the flaps to keep any dirt from getting in to them. And if you have little paintings, the flaps will protect them so they do not slip out of the sides. This kind of portfolio is reasonably priced and comes in a couple of different sizes.

Remember—there are no rules...

🎨 *Can I just put my paper directly on a table to paint? Or do you recommend another surface to paint on, especially when working on a 22" × 30" (55.9cm × 76.2cm) full sheet of watercolor paper?*
I paint on a board made out of basswood, which does not warp and is very lightweight. You can tape your paper to this particular board with drafting or watercolor tape; the wood is also soft enough to staple your paper to it. Basswood boards come in two sizes: one that accommodates a half sheet, the other a full sheet. I have seen artists use a thick piece of foamboard also.

🎨 *Is it necessary to stretch my paper? If so, can you explain how?*
This is really up to you. Try it and see if it suits you. I sometimes prefer the freedom to move the paper around if necessary. Stretching your paper will also prevent some buckling.

STRETCHING PAPER ON A BOARD USING TAPE
First wet your paper, front and back, with a big wash brush (see page 24), or soak it in a bathtub until limp. Let excess water drip off. Place paper on your board, and tape around all of the edges. There is watercolor tape made for this. Drafting tape is OK but *not* masking tape or brown shipping tape, neither of which peels off watercolor paper easily.

STRETCHING PAPER ON A BOARD USING STAPLES
Wet your paper as explained above. Place paper on your watercolor board, and staple about a half inch (1.3cm) from the edge of the paper all the way around the edges. Board made out of basswood is soft enough to take the staples. After drying naturally for a couple of hours, the paper will be tight and ready to use.

STRETCHING PAPER OVER STRETCHER BARS
Another fun way to stretch watercolor paper is to place the wet paper over stretcher bars and staple the sides as if you are stretching a canvas. After drying naturally, it'll be tight as a drum. Inexpensive stretcher bars come in many sizes. Be sure your paper is big enough to go over the sides, with enough overlap for the staples on the side of the bars; you can trim the paper when finished if need be.

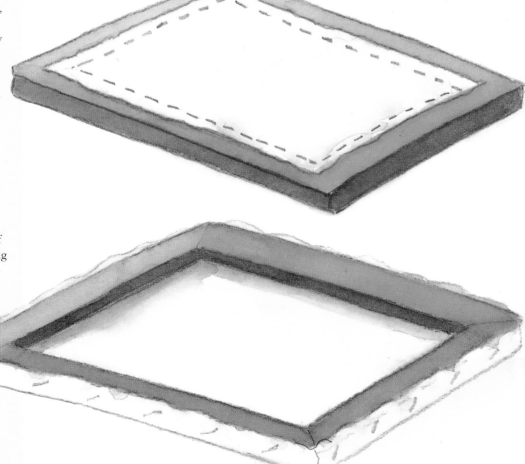

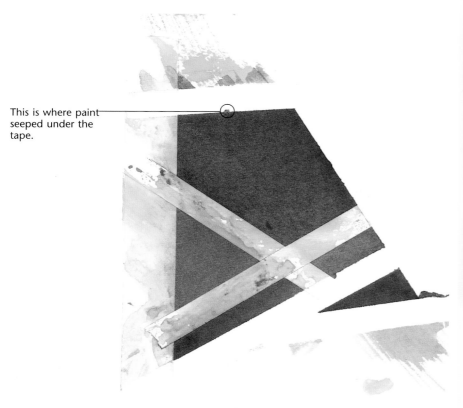

This is where paint seeped under the tape.

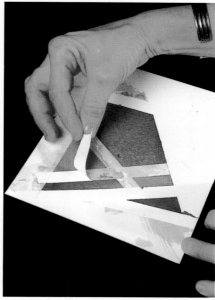

MASKING FOR HARD EDGES
If you want to block out a hard edge without masking fluid, I would suggest using watercolor tape or drafting tape. Be careful to press it down thoroughly; otherwise paint will seep under the tape as it did in one place here (see upper left). Masking tape will tear the paper when you peel it off, so I would not recommend that.

❧ *If I want a white border around my painting or want to block something out, what kind of tape can I use that will not peel the paper off with it?*
Drafting tape is one solution. Watercolor tape, made for this purpose, is also available. Masking tape will tear the paper when you remove it. Using the proper tape, follow the same procedure as shown on page 14, taping evenly and firmly along the edges of your paper, creating whatever width border you desire. Be sure to press firmly so the paint does not seep under the tape.

❧ *Can you explain a watercolor block versus a watercolor pad?*
A watercolor block is a bunch of sheets of paper glued together around all four edges except for one small area where they are not glued. Blocks are super for outdoor painting because the cardboard support on the back means you do not need to carry a board to support your paper. Also, the paper is prestretched. It may buckle a little if you use lots of water, but it dries flat. Blocks come in various sizes, surfaces and weights, mostly 140-lb. (300gsm).

However, if you use a watercolor block, when you finish a painting and it's still wet, you cannot do another one right away without disturbing the one you just finished. This is because getting to the next sheet means peeling off the top sheet, which is difficult to do if the top sheet is still wet. When you are waiting around for it to dry, you have missed out on another painting. If it's not *too* wet, you can carefully peel it off with a palette knife and set aside to dry. I now carry several blocks, and while one is drying, I work on another. Blocks are more expensive than pads, but worth it (yet I would still recommend less-expensive pads for your exercises).

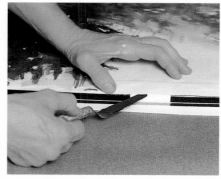

HOW TO TEAR PAPER OFF OF A WATERCOLOR BLOCK
When you finish painting on the top sheet of the block and your painting has dried, insert a palette knife under the top sheet where the edges are not glued. Carefully tear this sheet off the block by working the knife along the edges.

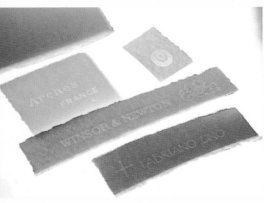

WATERMARKS OF DIFFERENT PAPERS
High-quality watercolor paper, man- or machine-made, has a watermark in at least one corner of each sheet. Sometimes you find the watermark on both the top and the bottom, sometimes in just one corner. Here are some samples of various watermarks as they appear on various painted watercolor papers. You can see the watermark on an unpainted sheet by holding the sheet up to the light. When you can read it, the right side of the paper is facing you.

What is a watercolor roll?
It is a roll of watercolor paper for artists who want to work bigger than 22" × 30" (55.9cm × 76.2cm). A roll comes in a couple of different widths and lengths, 140-lb. (300gsm) and 300-lb. (640gsm), hot-pressed, cold-pressed and rough.

How can I tell which side of the paper is the right side on which to put my paint?
Put your paper up to the light and you should see a watermark in at least one of the corners (some watermarks are more noticeable than others). When you can read what it says, you are looking at the right side of the paper, which has a different texture than the back. I will not say that it has a better surface because that will be your preference, so try them both. I was doing some intaglio printing for a Japanese artist and one of the prints had the watermark at the top and backward. The artist explained to me that the gallery would not accept the print. Another day, in a gallery in Carmel, I noticed that the watermark in one painting selling for a couple of thousand of dollars was at the top and backward. If you do ruin the front side you can use the back. Just crop off the watermark, and no one but you will ever know what side of the paper you painted on.

I'm a beginner and I just got brave enough to purchase my first full sheet of 22" × 30" (55.9cm × 76.2cm) watercolor paper. I am afraid to start with such a large painting. How should I divide my paper to get a couple of paintings out of one sheet?
A large sheet is intimidating for a beginner. It took me a while to get up the courage to paint on a full sheet. I tear my paper into smaller sheets, rather than cutting it with a mat knife, because when you tear it you can still have a deckle edge (the ragged edge on quality watercolor paper). Although the edges may ultimately go under a mat, there are times that the edges look so fine you may want to float your painting on 100 percent rag backing in a frame.

Is there anything I can do to prevent my paper from molding?
Many factors may contribute to this problem. Your paper may arrive moldy if you have it shipped to you. If you have a continuous problem with a batch of paper, send it back. It's important to inform the art store so its personnel can inform the distributor. This helps everyone involved a great deal. The distributor can track it by the batch number (located on a label on a package of paper) and pull all those batches off the shelves.

Maybe you stored your paper in a damp area where there is no air circulation. If you use a lot of water when you paint, you must find a way to dry your paintings as naturally as possible, unless you want to stand there with a hair dryer. Catalogs carry drying racks, and you can also make a homemade one. Just make sure your paper is not sopping wet when you put it in the rack, or the design of the rack will come through to the front, which happened in one of my workshops. A student placed a very wet painting on the rack, and when it dried it had the pattern of the rack, with diagonal stripes that dried much darker than the rest of the painting. She was a beginner and ecstatic that she had made such a cool thing happen in the background because it looked like a trellis.

I have developed a system for drying. A friend made me some drying racks similar to the ones you see in a bakery so the air gets under the paper

too. I have also used a table fan to help circulate the air, and another friend gifted me with a ceiling fan, which is a tremendous help.

What is sizing? Do I need to remove sizing from my watercolor paper before I put down my paint?

Sizing is a glue or gelatin added to your watercolor paper during the manufacturing process. Sizing controls the absorbency of the paper. Think of it this way. If your paper is 100 percent cotton, it's very absorbent. If there were no sizing, it would be similar to painting on an ink blotter. Sizing allows you to manipulate your paints. Some papers have more sizing than others, and your paint will not grab the paper easily. In that case, take a wash brush of clear water and brush the water onto the paper as though you were painting the entire surface with water. Wet the entire sheet, or soak your paper in a clean bathtub for a few minutes. You will become more familiar with the sizing on the different papers when you experiment with different brands of paper and decide which paper suits your needs.

Remember—there are no rules...

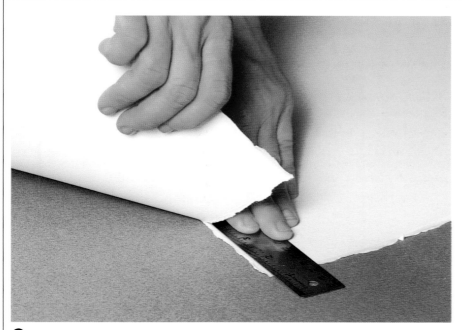

❶ TEARING LIGHTER-WEIGHT PAPER TO SIMULATE A DECKLE EDGE

Simulate the ragged edge on quality watercolor paper that is 140-lb. (300gsm) weight or lighter. Make sure the surface you are working on is clean. Place the wrong side of your paper face up. Hold your paper up to the light. You have the wrong side if the watermark is backward. Make a tiny *x* in each corner on the wrong side of the paper. When the watermark appears in only one corner, and you tear your paper into four sheets, three of those sheets will not have the watermark on them. With the little *x* on the wrong side, you will be able to tell later which is the wrong or right side. With a pencil and ruler, mark where you want to tear your paper. Using a ruler with a cork backing or a strip of masking tape all the way down the back so it will not slip, place the ruler on the paper, lined up with the pencil marks. Apply pressure to your ruler. Then make a little tear at the top of the paper to get it going and slowly begin tearing at the top and pulling the paper down carefully, tearing the paper in steps. The hand with the pressure on the ruler should move down the paper simultaneously with the hand that is tearing the paper.

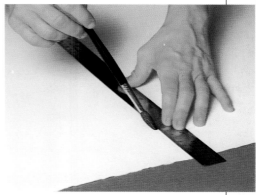

❷ TEARING HEAVIER PAPERS TO GET A DECKLE EDGE

You will need a little more strength and pressure for tearing heavier paper, such as 300-lb. (640gsm). Soften the paper and make it a little easier to tear by drawing a line with a wet brush along the ruler's edge where you will tear the paper. Wait a few seconds for the paper to soften. Tear in the same manner as described at left.

NO INTERRUPTIONS, PLEASE

If you have to work with lots of distractions, try wearing headphones and listening to your favorite music. It helps you focus on your painting and blocks out the noise. This is your time. Do not let yourself be interrupted by anything.

Remember—there are no rules...

TRY SOMETHING DIFFERENT

This was my first experiment painting on Aquarius II paper. I generally use a lot of water when I paint and it amazes me how little this type of paper buckles. It is acid free, cold-pressed and machine-made out of both synthetic and cotton fibers. I enjoyed all the surprises that occurred while working on it. You must try it!

Sometimes my paper acts like an ink blotter, absorbing paint quickly instead of letting it blend. I cannot push the paint around, and I have no control. Is the paper defective?
No. It is a sizing problem. The paper's absorbency, or lack of it, has to do with the amount of sizing applied to the paper during the manufacturing process. Too much sizing will resist the paint—a predicament that comes with its own frustrations. Too little sizing will suck up the paint like a blotter, giving you little or no working time.

Different brands have different amounts of sizing added. You have to determine this yourself by experimenting with different brands and becoming familiar with any paper you are thinking about using.

When choosing a paper, the biggest thing you must remember about sizing is that you can wash it off, particularly if you use a lot of water, as I do with my glazing. It is not the manufacturer's fault.

One time I put a watercolor wash on my paper and uneven bumps popped up all over the surface of it. When it dried it was smooth again, but the color was so uneven I could not continue. Is this normal?
No, this is not normal. It is another sizing problem and happened during the manufacturing process, leaving sizing in certain areas of the paper only. Some of your paint took where there was sizing, and where there was none, no paint took to the paper at all.

Does the surface of my paper have to be different for each painting?
No, not necessarily, but it is something to consider. Experiment with many surfaces and weights. Some papers are even whiter and brighter than others. Find out what does and does not work for your style of painting. Soon you will find a favorite that suits you or a particular piece. I love trying new papers.

TURNER SUNSET
Watercolor on Strathmore Aquarius II paper
11" × 14" (27.9cm × 35.6cm)
Private collection
Photo by Ron Zak

≈ *What kind of pencil and eraser should I use for making a light preliminary sketch on my watercolor paper?*

Use an HB pencil. Use a kneaded eraser because you want to lift off the pencil marks gently. You do not want to scrub from side to side on watercolor paper, especially if you are doing something delicate, because the eraser marks will damage the paper.

≈ *What is watercolor board?*

These are thick boards made for watercolor painting. You do not need to stretch them. Strathmore 500 series illustration board is 100 percent rag (cotton), acid-free paper, which creates a balanced tension that prevents warping.

≈ *The big sheets of watercolor paper are so expensive. It is intimidating. Can you please help me make the leap to more expensive paper?*

Think of it as my watercolor teacher did. What if you create your masterpiece and it's on cheap paper? Think positive and be prepared. You never know when you are going to "hit it." Once you start painting on the good watercolor sheets, you will not go back. Watercolor will be fun for you, and you will know immediately why you paid more. Get the best you can possibly afford.

TURN IT AROUND

Years ago the painting below was my star piece in two shows. In the first show, people would walk up to it, look for quite a long time and leave. No one bought it. Back then, sales were, to me, the measure of whether I was a good artist or not.

At the second show, it was the same thing. So while packing it up, I said to this beautiful painting that I had poured my heart and soul into, "Well, there must be bigger plans for you." Months later it was accepted into the American Watercolor Society's traveling show—and it won the Winsor & Newton Award.

Turn to your rejections and disappointments; just say, "There must be bigger plans for you." You will feel so much better. It pulls you out of the bottom of the pit and gives you hope. Practice turning your thoughts around. It really works.

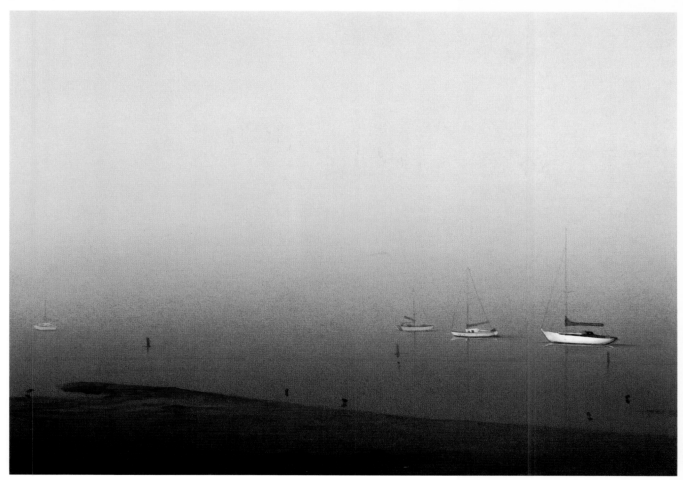

AND GOD CREATED FOG
Watercolor on 300-lb. (640gsm) hot-pressed paper
15″ × 22″ (38.1cm × 55.9cm)
Private collection
Photo by Ron Zak

TREE SPIRIT
Watercolor on 300-lb. (640gsm) Lana hot-pressed paper
21″×29″ (53.3×73.7cm)
Collection of the artist
Photo by Ron Zak

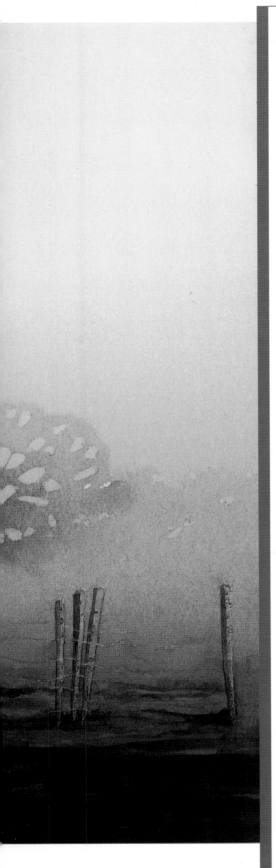

Brushes and Their Care

Because watercolor brushes are such important tools, it's vital to find the ones that are comfortable for you. They do not have to be the most expensive brushes, as long as they are right for you.

As a beginning student, you may feel overwhelmed the first time you walk into an art store and see the assortment of brushes available, even if you go in with a list from a teacher. All shapes, sizes, colors and prices! They all look great, but you do not know one from the other. Find a sales clerk who *knows* about watercolor and brushes. I remember when one of my students came to class with an oil brush; the sales clerk said it was a watercolor brush.

Start out with four or five basic brushes (see page 26). Gradually experiment with all kinds, adding more to your collection as you learn about brushes and find ones that work for you. Buy them and try them. If none of the brushes I suggest work for you, try others. Keep trying until one or more clicks. You may find a brush you are absolutely in love with, and your best watercolor-painting buddy cannot understand how you could possibly work with such a thing.

When you find watercolor brushes you feel comfortable with, that's when the magic begins. All sorts of things begin to take place. You feel that maybe you really can paint after all. Now that you have the right tool and are happy with your brush, you begin to pray that what you want to express will come right out of the tip of that brush.

Your watercolor brushes will become your friends. Somehow they seem to stay with you like favorite pieces of clothing. You use your favorite brush so much it becomes frayed, like an old sweatshirt, but you do not care; you still paint with it. One day you realize you can't use it anymore because there are no bristles left. Do not throw your old brushes away, however, as someday they may come in handy for scrubbing off paint. Order another one just like that one. Be patient. You need to break in a new brush. Give the new one some time.

I recommend particular brushes to start out with, but I do not know what your personal preference will ultimately be. Only you will know that. I want to keep it simple enough for you to know a little about what you are going to buy and what I have seen work for other artists. With the brushes I suggest in this chapter, you will be able to do many different things. Experiment and have fun with them. This is how you learn.

One day I was speaking with some preschoolers about art. In response to the colorful painting I brought in, one girl raised her hand and said, "What kind of brush did you use to make such a pretty picture? It sure did a good job!" As though the brush did all the work. You know what? The right brush really does make a difference.

JUST ONE STROKE

Have you ever looked at a painting that knocked your socks off because of just one brushstroke? One brushstroke can say so much. That's a difficult thing for an artist to learn and does not come easily. It's too simple. We think more is better and want to fill up the entire sheet, leaving no breathing areas. I believe we learned this in grade school when we had to color in everything and stay within the lines. Remember?

TURN IT OFF

Watch less television, or none at all. I'd like to think that the masters created so much during their lifetimes because they had no televisions, computers or phones. Watch how the phone is a temptation, and talk on it less. Notice how much time you spend on it each day and how much time you really have to be on it. The key is to use it only when you must. You'll be surprised at the amount of work you will get done.

What is a watercolor brush?

Watercolor brushes come in a variety of fibers: natural hair, synthetic hair and a blend of natural and synthetic hairs. Watercolor brushes are very soft and are made specifically to use with watercolor paints.

Can you explain more about brushes made from natural hair, synthetic hair and blends?

Natural-hair brushes are made from animal hair, such as sable, ox, goat, hog, squirrel, mink or camel. They generally have a good point, hold more paint than synthetic brushes and are also more expensive. Kolinsky sable brushes are the top of the line.

Synthetic brushes are made of synthetic materials. A synthetic brush generally holds less paint and does not have as fine a point as a natural-hair brush. Though synthetics are the least expensive of the three types of brushes, that does not mean they aren't any good; there are some wonderful synthetic brushes on the market today.

A blend is a combination of natural and synthetic hairs. These are becoming more and more popular, as they offer the best of both worlds in one brush. A blend is a good alternative to an expensive sable brush, though some advertisements can be misleading because the blend may only have a tiny percentage of red sable and the rest synthetic hairs.

Generally, the more you pay for it, the finer the brush is. But whether it's a Kolinsky red sable, a synthetic or a blend, a good watercolor brush should hold a good amount of paint and water so you don't have to keep going back and forth to pick up more paint.

What is a round brush?

Rounds are completely round with pointed ends. Because this type of brush is so versatile, it is the most commonly used brush among watercolor artists. Rounds come in a variety of sizes, hold a great deal of paint when wet and have tapered points for fine lines and detail.

belly —

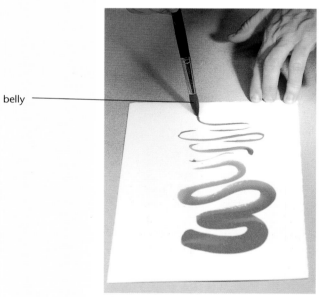 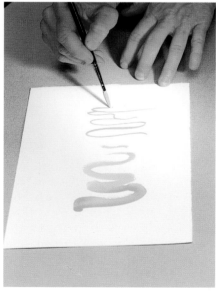

This is a Kolinsky red sable round (Isabey 6227Z series no. 14). The belly is round where large amounts of water and paint are stored, yet it has a fine point for details.

This no. 7 Kolinsky red sable round (Isabey 6227Z series) was used for all of these lively brushstrokes. The smaller rounds are used for more detail.

᠌ *What is a flat brush?*

Flat brushes have broad, square shapes ranging anywhere from ⅛-inch (3mm) to 2-inches wide (5.1cm). They're available in natural hair, synthetic hair or blends. Some have beveled handles for scraping color off the paper for texture effects. Flat brushes are often used for applying large areas of color.

This is Holbein's KHX Eldorado series 1½-inch (3.8cm) flat made from the finest-quality blend of synthetic and natural hairs. With one single stroke you can apply large areas of color and create all sorts of configurations. It's wide enough to achieve an even wash, and boy, does it hold the paint and water!

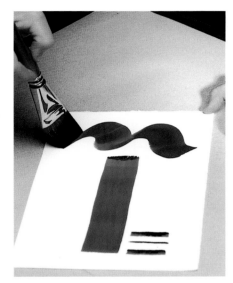

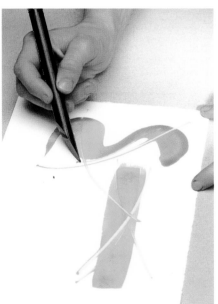

This popular sabeline aquarelle 1-inch (2.5cm) flat made by Grumbacher has a short green plastic beveled handle. The brushstrokes can be just as exciting as those of a wider flat. A beveled handle can be handy for making textures by simply scraping through your paint. While your paint is still wet, turn the brush around and use the beveled handle to create designs and textures by scraping right through the paint. You must scrape hard enough to make your designs but gently enough so you don't scrape through the paper.

Remember—there are no rules...

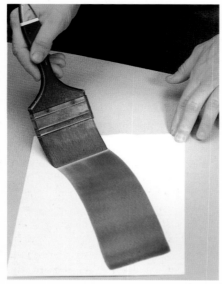

This Robert Simmons 3-inch (7.6cm) Skyflow wash brush holds a great deal of paint and water for creating wide, smooth brushstrokes.

What is a wash brush?

This type of brush is a little wider than a flat and is used for applying washes (thin layers of paint) on your paper (see chapter four). Wash brushes range from 1 inch (2.5cm) on up to larger sizes. I would not skimp on this brush. If you want even washes, it will benefit you to get the best. You can become discouraged with wash techniques if you don't buy a quality brush. For a smoother wash, I recommend wider wash brushes. Wide flats may be used for washes too.

This Holbein 2-inch (5.1cm) hake brush comes in many sizes. It is my favorite wash brush and a good one to start out with.

What is a Funny Brush?

Funny Brushes are exactly that—funny looking and just plain fun! Experiment with them. They save time painting leaves, grasses and bushes, creating all sorts of textures in no time at all. They come in three sizes. Be creative with them and your other brushes. I have prepared a small demonstration on how to work with Funny Brushes on page 25. In my watercolor painting *After Noon*, the bushes above the white fence on the right were painted with a Funny Brush and a round brush. Funny Brushes are available in most catalogs.

These are Funny Brushes. They come in three sizes: small, medium and large. I have painted a small demonstration (shown on page 25) for you so you can see one way they can be used.

AFTER NOON
Watercolor on 300-lb. (640gsm) cold-pressed paper, 21" × 29" (53.3cm × 73.7cm)
Private collection
Photo by Ron Zak

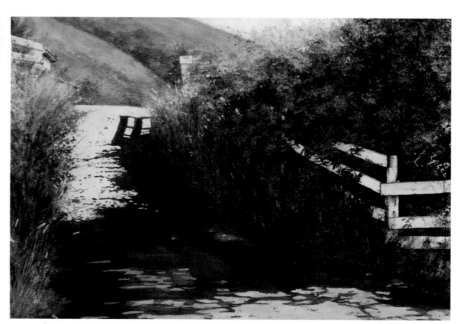

Bushes above the fence were made with a large Funny Brush in combination with a large round brush. On the left side of the road I also used the Funny Brush and a round brush. Where the light is hitting the tops of the bushes, I added yellow with a Funny Brush.

Using a Funny Brush

 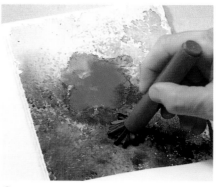

❶ PREPARING YOUR FLOWER

Mix a flower color of your choice on your palette. With whatever brush you choose, paint a simple flower on your watercolor paper, making your shape as interesting as possible. Let it dry.

❷ PREPARING BACKGROUND WASH

Mix together Sap Green and a little Sepia until you get a rich, dark green. Take some of that mixture and, on another spot on your palette, mix some water with it, making the color lighter in value. Take your large round brush and paint in a layer (wash) of that light green around the flower, as if you were painting in the leaves (but not the detail of the leaves). Let it dry.

❸ MAKING YOUR LEAVES

Take any size Funny Brush (I used the large one here). Scoop up the dark green mixture of paint. Saturate the brush with your green paint. The brush should have mostly paint and very little water. If there is too much water, it will run right out of the brush onto your paper, making a big blob of water and no design. Begin dabbing the brush with some pressure on the paper, creating your designs, leaving the lighter green areas showing through. Our tendency is to cover up the whole page, losing the light areas. Keep this in mind when making your designs. You must leave some light areas where the sun is hitting your leaves. These brushes are very durable, so don't be afraid to push, twist and scrunch them any way you want.

WHAT YOU NEED

- Brushes:
 Large round
 Large Funny Brush
 Other brush(es) of your choice
- Watercolor paper
- Palette
- Paints:
 Sap Green
 Sepia
 Other color(s) of your choice
- Water

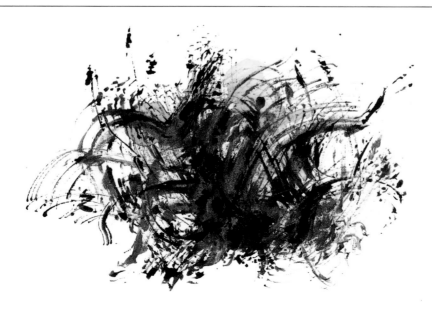

TRY GRASS STROKES TOO

Funny Brushes also make great grass strokes. Play with them and have a ball. Try all the sizes for different grass effects.

RECOMMENDED BRUSHES FOR THE BEGINNER

In addition to the brushes below, I also recommend a couple of old masking brushes.

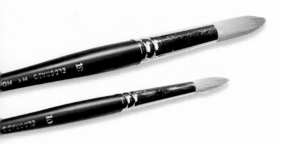

Two round brushes, one large no. 18 and one small no. 10 (for more detailed work). These are from Holbein's HX Eldorado series, made of a superb blend of synthetic and natural hairs.

One flat brush in a blend. This is a 1-inch (2.5cm) Grumbacher Aquarelle with a plastic beveled handle.

One 2-inch (5.1cm) Holbein wash brush made out of goat hair.

PAINT EVERY DAY

For at least one hour, let yourself get into a rhythm, and begin to feel really good about yourself. One hour just for you. If you get into overtime, that is OK. Pretty soon you'll want to paint more and more and won't be able to live without it. Early in the morning is best because you will feel good about yourself the rest of the day.

What brushes would you recommend for a beginner to start out with?
- Two rounds in a blend—large (such as no. 18) and smaller (such as no. 10, for more detailed work)
- A 1-inch (2.5cm) flat in a blend, preferably with a beveled handle
- A 2-inch (5.1cm) Holbein wash brush made out of goat hair
- A couple of old masking brushes (see below)

How should I clean my watercolor brushes?
When you finish painting, clean your brushes immediately by adding a little water and swirling them *gently* on a cake of soap until you have loosened all the paint out of the brush. Rinse thoroughly. While still wet, reshape the tips with your fingertips. Place brushes flat, with their heads hanging off the table to dry, if possible. If you stand them with the wet heads of the brushes up, the water seeps down into the handles and can rot the wood.

What is a masking brush?
Masking brushes are not a "type" of brush, like a round or a flat; they are just inexpensive brushes (under two dollars) with good points for applying masking fluid. When applying masking fluid, your brushes gum up quickly. Do not use your watercolor brushes for masking because the life span of a masking brush is short—that's why you want inexpensive ones.

Cheap Joe's Art Stuff (a mail-order catalog) has a masking kit containing masking fluid, a masking fluid pickup, a no. 2 Uggly Brush and instructions. Cheap Joe's even makes the brush with a bright yellow handle so you do not confuse it with your better brushes. Of course, you can also buy masking fluid and brushes separately. If you are blocking out larger areas with masking fluid, any clean brush will do, but *do not use your watercolor brushes*. See page 54 for a demonstration of masking.

Can I clean my masking brushes when they are all gummy? They look pretty hopeless after I have used them only a couple of times. Should I discard them? Do you have any suggestions?
The life span of a masking brush is short, but there is hope, so do not throw them out right away, and take precautions. Before applying masking fluid, dip your brush in a mix of water with a drop of soap in it. Then wipe the brush so there is no soap in it but it is still moist. Then apply masking fluid. This prolongs the life of a masking brush. Never go into masking fluid with a dry brush, or it will become useless almost immediately. While masking be sure to clean your brush once in a while in a soapy solution. You'll know when because the brush will start to gum up on you.

Now, when finished masking, you can clean your masking brush with lacquer thinner or ethyl alcohol (available in the paint section at hardware stores). Make sure you are in a well-ventilated area while doing this.

How do I know what brush to use for a specific technique? Where do I begin?
That's a good question. I have prepared a simple step-by-step demonstration using all of the five brushes I have recommended, showing each of these brushes used in a simple painting.

Only Five Brushes

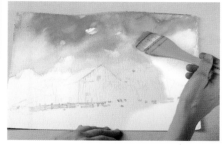

1 SKETCH, MASK, SKY
Draw a light sketch. With a masking brush, mask your fence (see page 54). Let dry.

Dip your no. 2 wash brush in water. Apply a layer of water in the sky as if putting on color. Your paper should not be too wet; just enough for a sheen. Mix a *little* French Ultramarine Blue (more water than blue). Add to the sky, leaving white for clouds. The blue will diffuse, leaving a soft look (see page 56). Let it dry.

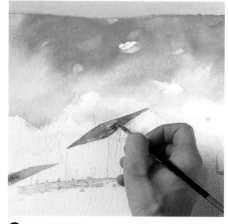

2 BARN ROOFS
Mix some Cadmium Red, Burnt Sienna and a touch of Sap Green. Take your small round brush and paint in the red roofs. Paint your brushstrokes at the same angle as the roof's slope. Let it dry.

WHAT YOU NEED

- Brushes:
 Masking brush
 Holbein no. 2 wash brush
 Small round brush
 Large round brush
 Flat brush
- Sketch pencil
- Watercolor paper
- Masking fluid
- Palette
- Paints:
 French Ultramarine Blue
 Cadmium Red
 Burnt Sienna
 Sap Green
 Sepia
 Thalo Yellow Green
- Water

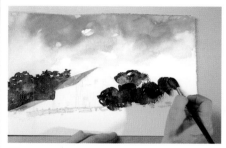

3 BACKGROUND TREES
Mix Sap Green and a touch of Sepia until you get a rich, dark green. Lay in the trees using your large round brush, making sure the trees are varied, not just green blobs. Let it dry.

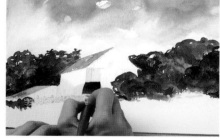

4 SHADOW SIDE OF BARN
Mix French Ultramarine Blue and Burnt Sienna to get a neutral gray. The more water you add, the lighter it will become. Use your flat and go down the side of the barn in the direction the wood is going.

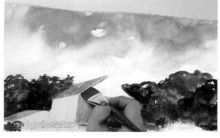

5 SHADOWS UNDER ROOF
When dry, mix a darker gray with the same colors. With the tip of your flat, holding the brush almost straight up, dab under the roof. Let it dry.

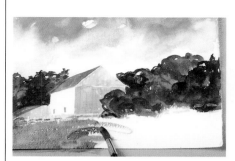

6 FOREGROUND
Mix a lighter green (add water to the mix you have, plus a touch of Thalo Yellow Green). Take your large round brush. Create brushstrokes in the grass. Let it dry. With your small round add tree trunks and limbs.

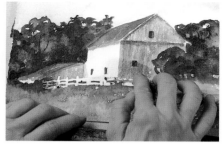

7 REMOVAL OF MASKING FLUID
When everything is dry, peel off the masking fluid with your fingers, or use a rubber cement pick-up to lift it out, rubbing gently.

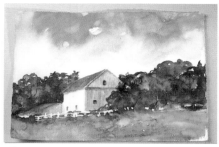

8 CONGRATULATIONS
You have just finished a little painting using the five basic types of brushes I recommend.

🦢 *How would you recommend I store my brushes?*

You must protect your brushes as much as you can, and there are several brush holders on the market. I store my brushes flat on the table or in my denim brush bag when I have to transport them. The denim brush bag is compact, easy to carry and holds several sizes of brushes. The bamboo roll-up brush holder shown here protects brushes from damage and provides a good surface for drying brushes. Holbein also makes the sturdy, clear, telescoping container shown here; it pulls out like a telescope, for transporting small or long brushes.

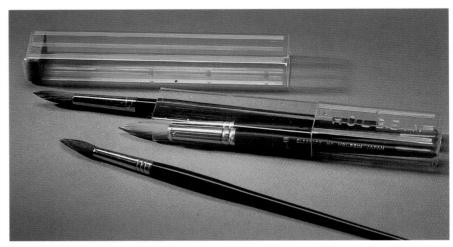

DENIM BRUSH BAG
This bag has pockets for different-sized brushes, a flap that folds over them so they won't fall out and a tie for extra protection.

PLASTIC BRUSH CASE
This sturdy, clear, telescoping plastic brush case can carry your short brushes, and it pulls out like a telescope for longer ones. Cool.

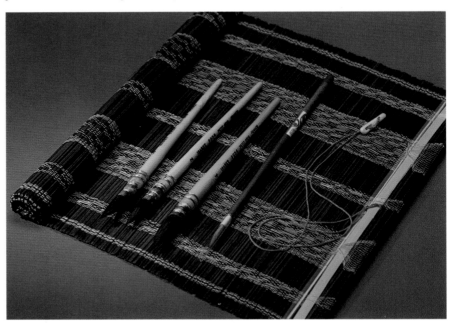

BAMBOO BRUSH HOLDER
This is a bamboo roll-up watercolor brush holder. It provides a good surface to dry brushes on and protects brushes from damage.

Do brush sizes vary with different brands? I had a no. 12 round and need another one. I found some great brushes on sale, so I ordered another no. 12 round. When I received my new brush, the head was a lot bigger than the old one.

I have had that happen to me; not only was the head of my brush larger than the other one I had, but the handle was shorter. Yes, brush sizes do vary with different brands. It's difficult to tell what size you are actually going to get when ordering through a catalog. Some catalogs have photos of the actual sizes of the brushes, which is helpful. If you are in a class, you can get an idea of sizes in different brands by seeing what the other students have. Maybe they will let you try them out as well.

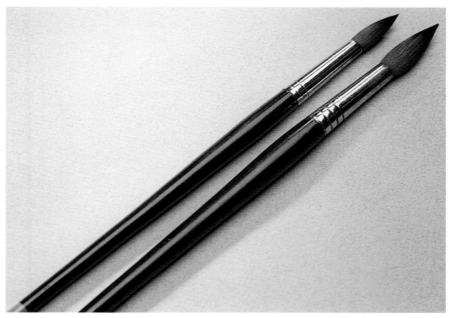

SAME NUMBER, DIFFERENT SIZE
Notice the difference in the sizes of these brushes, which are both no. 14 red sables in different brands.

Why is the black enamel on the handle of my expensive sable brush cracking?
This happens when you leave your brushes sitting in the water. When they get waterlogged, the enamel starts to crack and peel after a while. Sometimes I get so into my painting that I forget where I put my brush, and there it is sitting in the water.

Can I use an oil brush with watercolor paints?
You can use anything you want, any kind of brush you desire. It's your painting. I did not know until recently that I could apply watercolor paint with soft sable oil brushes. Use whatever is comfortable and works for you.

LIFTING OFF COLOR

An old, small oil painting bristle brush is good for scrubbing dried color off your paper. I use an old hog bristle filbert brush. A filbert is a flat brush with an oval-shaped point. Mine is worn almost down to the ferrule (the metal ring around the brush handle), which makes it good and stiff for scrubbing and lifting like an ink eraser. Rounded at the top, a filbert is easy to manipulate into the place where you need to lift off the paint. Be careful not to rub too hard on your paper, or you will go right through it. Be gentle. A watercolor brush is too soft for heavy lifting jobs, such as lifting off dry paint. You may use a watercolor brush to lift off wet paint, yes—when dry, no.

Remember—there are no rules...

DRYBRUSH

Drybrush is a technique, not a brush; you can use any brush for the technique of drybrushing, which will also work on any paper surface. However, if you want to give your texture an extra boost, try using rough paper and a flat brush. Load your brush with almost all paint; use little water. Drag it across the paper, barely touching the surface, leaving behind some of the white texture of the paper.

Is drybrush a brush or a technique?

It is a technique of painting with very little color or moisture on the brush, creating a "skipped" or "missed" effect of the paint on the paper. It is especially useful when you want to create texture in your painting, as on a barn, the bark of a tree, a fence post or blades of grass. You can use any type of brush, depending on what you want to achieve. Here, in my painting *Celebrate the Earth,* I used this technique on the crates to create the roughness of the wood.

CELEBRATE THE EARTH
Watercolor on 300-lb.
(640gsm) Lana rough
paper, 21"×29"
(53.3cm×73.7cm)
Private collection
Photo by Ron Zak

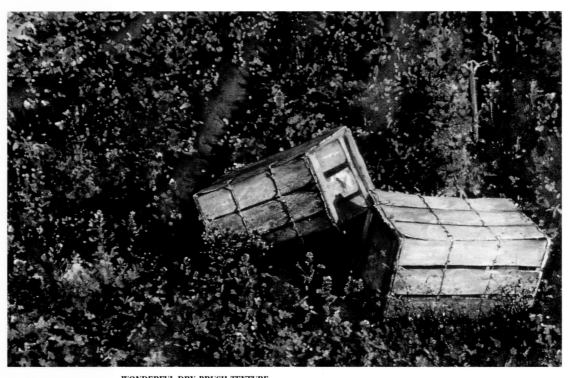

WONDERFUL DRY-BRUSH TEXTURE

These farm crates were done with a dry-brush technique, giving them wonderful texture.

IT TAKES PRACTICE

How much water and paint should you mix in your watercolor brush to get the right consistency for the color you want on your paper? I have observed that most beginners use entirely too much water and very little pigment. With practice you will learn.

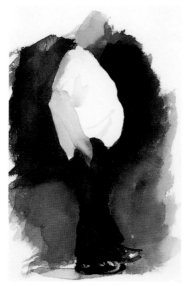

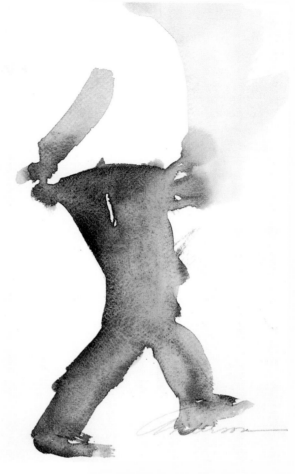

LIVELY, POWERFUL BRUSHSTROKES

I want to show you how powerful a brushstroke can be by show-ing you one of Serge Hollerbach's watercolors, below, and what I did in his workshop several years ago. Serge asked the model to walk around while we sketched him. I could barely sketch a model still, let alone moving! It was a struggle. At the end of the week, we were to pick our favorite paintings. Serge would look at them and pick his favorites. My favorite was the one at upper left I thought it was pretty good, for me. Serge came, tossed it aside and picked the one at right, my least favorite.

The one I liked at first has no life. Serge was looking for move-ment, some sort of feeling. The one on the right is much more alive.

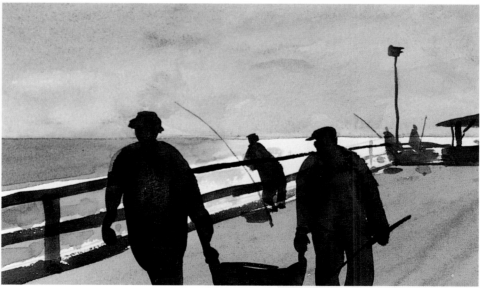

EXPRESSIVE BRUSHSTROKES

In this watercolor, *Simple Elegance*, Serge captured so much movement and feeling with very few brushstrokes. You see the movement of the fishermen walking off the pier with their catch of the day. You can feel the heaviness of the basket of fish they're carrying; you feel the man leaning over the railing; and you feel the light on the water. See how powerful one stroke can be? When you know when to leave that stroke alone, you've become a master.

SIMPLE ELEGANCE
Serge Hollerbach
Watercolor on 140-lb. (300gsm) cold-pressed paper
9 ½″ × 13″ (24.1cm × 33cm)
Collection of the author

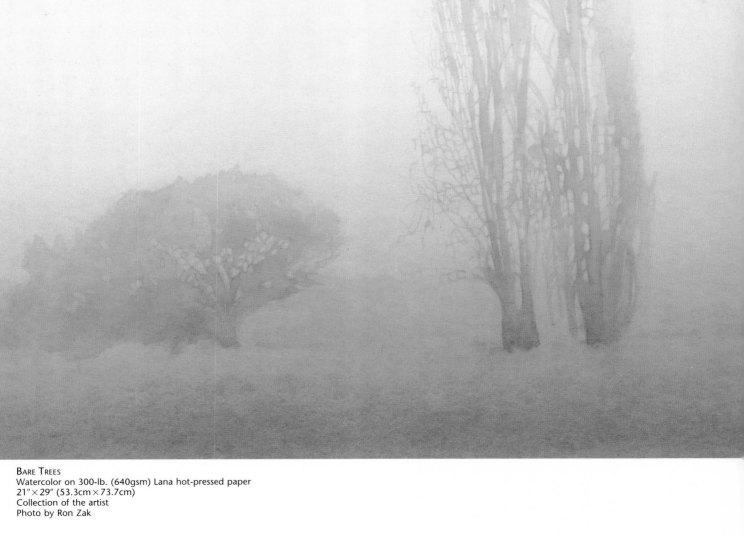

BARE TREES
Watercolor on 300-lb. (640gsm) Lana hot-pressed paper
21″×29″ (53.3cm×73.7cm)
Collection of the artist
Photo by Ron Zak

Paints and Palettes

As your talent develops you will fall more and more in love with watercolor. You will also develop your own palette of colors that work for you, as well as different brands of paint you prefer over others. Like your brushes, they too will stay with you like a favorite old sweatshirt.

On the other hand, you should always be open to experimenting with new paints. Do not get too comfortable or you will not grow. I have had many different color palettes in the last thirty years. When we grow as artists, our palettes change. If we do not grow, we keep making the same old boring paintings. Make every painting a challenge!

Color is critical to the success of any painting, in any medium. It can make or break a painting. Color is a powerful way to express yourself as a watercolor artist. Color can be light or dark (value), warm or cool (temperature), weak or strong (intensity). Color can invoke emotion: You can create moody paintings with muted colors, happy paintings with bright colors, and peaceful paintings with softer colors. Look at all the art out there and how each artist expresses himself with color. The possibilities of color are endless and wonderful!

In this chapter you will learn about paints, some of their characteristics, how to set up your palette, why it's useful to set it up in a certain order and some ways to use color. By doing some simple, fun exercises, you will become better acquainted with some of the possibilities of paints. It's important to take the time to experiment and play with colors. Learn how much water to mix with your paints and what colors to mix together for certain results. Learn how to mix all sorts of colors from just two or three, and what colors to mix so you do not get mud. Mix two colors and add a third, just to see what happens. Experiment with everything.

GETTING LOWER PRICES

Investigate the various mail-order art supply catalogs that advertise in art magazines.

The term "mud," in reference to watercolor, means a lack of vibrant color. Avoiding mud is one of watercolor's greatest challenges, because while it does not take long to get into the mud, it's tough to pull your painting out once you are in it. Mud happens to watercolor artists at all levels of experience, so don't give up if it happens to you.

Mud can occur when you overwork an area of a painting, when you buy inferior paints or when you lose the vibrancy of your original colors by mixing improperly. That's why it's important you learn to select the right paints and color mixtures. In chapter four I will explain some ways to avoid mud, some ways you can get yourself into the mud and some ways to pull yourself out of the mud.

What kind of paints do you recommend for a beginner, and why?
There are many choices out there. Watercolors come in tubes, cakes, pans, kits, crayons and inks. I recommend you start off with the best tubes of watercolors. Tubes come in many sizes, brands and prices; different colors range in price also (for example, Cadmium Red is usually more expensive than Yellow Ochre, and Vermilion is always costly).

Tubes of watercolors typically labeled "professional," "artists'-quality" or "finest" are the best and most commonly used. You can always tell the professional brands by their relatively higher prices, but they are worth every penny. There is more pure pigment in each tube than in so-called student-grade watercolors. If you use professional artists'-quality paints from the start, you will get the brilliant colors you have always admired about watercolor. It's critical for you to experience this. If you begin with inferior paints, you will get inferior colors.

This is about making the best painting you have ever created. Remember, it may be your masterpiece. You deserve the best so the creative force can come forth from within you and shine. Go for it! Look for discounts on professional artists'-quality watercolors in mail-order catalogs. You can start with a few good tubes of paint, such as Alizarin Crimson (red), Aureolin (yellow) and French Ultramarine Blue. Slowly add more colors to your palette as you can afford them. If you cannot afford the best, then get second best. Please do not start with the cheapest brands. You will probably not be happy with your results, and you may even spend more money in the long run.

What are student-grade paints? Are they right for me, since I am a student?
Though usually described as being for beginners or the price conscious, and often made by the same manufacturers as the professional paints, these are the ones you *do not* want. Bear in mind that you get what you pay for; because these paints are priced quite a bit lower than the artists'-quality paints, you may think it's a deal because the paint is by the same manufacturer.

Student-grade colors are not of the finest quality, which is why they cost less. Since students are traditionally price conscious, the manufacturers intentionally make a line of lower-quality paints. They have much less brilliance because there are more fillers in each tube and less pure pigment than in professional artists'-quality paints. Because of this, they look muddier, and *mud* is a scary word in watercolor. Why would you want to squeeze mud out of a tube, whether you're a beginner or not? Buy the finer, professional artists'-quality paints if you can.

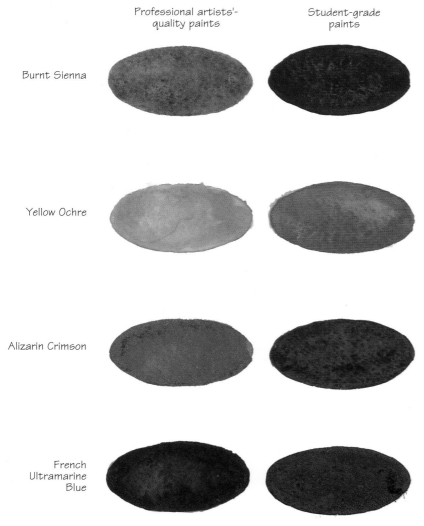

Professional artists'-quality paints Student-grade paints

Burnt Sienna

Yellow Ochre

Alizarin Crimson

French Ultramarine Blue

COMPARE

Can you see how much muddier the student brands are? The colors on the right look brighter. No sense in squeezing mud out on your palette from the get-go just to save a few pennies. We get into enough mud with watercolor as it is!

Do professional artists'-quality paints vary from brand to brand? How do I know which brand to buy?

Colors with the same name do vary from brand to brand. You will find your favorite colors in certain brands after you try a few and work with them. I sometimes make comparison charts of different brands of the same color; I have a chart of different brands of Sap Green. You can make your own charts by putting the colors down on each chart when you get a new color of a different brand. Put each color on a different chart, and mark the brand name next to the color swatch in pencil. Eventually you will learn which brands you prefer.

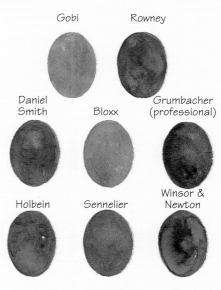

Gobi Rowney

Daniel Smith Bloxx Grumbacher (professional)

Holbein Sennelier Winsor & Newton

SAME COLOR NAME, DIFFERENT BRANDS

These Sap Greens represent different brands of paint. See the difference? It is helpful to make yourself charts like this, so you learn which brand of each color you prefer.

❧ Can you recommend some kind of system to keep track of my colors by brands so I can see what one brand's color looks like versus another before I apply the color?

When your curiosity and enthusiasm about color build up, you will want to try many different brands. I eventually tried so many I could not keep track. Today, I have paint charts for each brand. When I get a new color, I paint it on the chart. This is also helpful when you are looking for a particular color.

MAKE CHARTS BY BRANDS

Try different brands of paints. I decided to make color charts for each brand, keeping warm colors together and cool colors together, so I would learn. When I get a new color in a certain brand, I still put it on the chart. I leave spaces for new warm or cool colors. If you need a particular color, you can go right to your charts and find it. For example, if you wanted a really bright red for something, the charts would help you immediately decide which red in what brand.

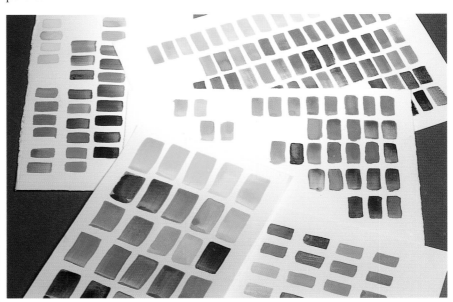

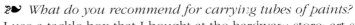

❧ What do you recommend for carrying tubes of paints?

I use a tackle box that I bought at the hardware store; art supply catalogs carry the same thing, but you pay more for it. I have also seen my students carry their paints in clear plastic sewing or tackle boxes with lids. Be extra careful when traveling, particularly by plane. I used to carry all my colors in one bag, until a tube of Sepia exploded all over them. What a mess! Tighten all the lids on your tubes, then put reds and oranges in one zippered plastic bag, yellows in another and so forth.

❧ Help! I have tubes of paint everywhere. How should I organize my paints to be able to find them easily?

One way I solved this problem was to buy several baskets at a secondhand shop. I put the reds in one basket, the blues in another and so on. Yet I have to admit that my organization of colors only happens once or twice a year. For any particular painting I am working on, I keep the colors in a separate area and add to the pile as I work. It really does not matter how you do it, as long as you can easily grab a new tube when you need it.

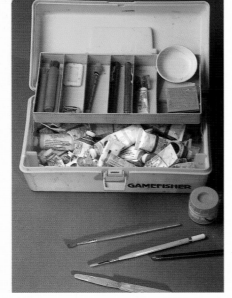

CARRYING PAINTS

I have carried my paints—not my good watercolor brushes, however—in this inexpensive tackle box for years. Carry your sable brushes in a brush holder to protect them. The brushes here are only my masking brushes and Funny Brushes.

> *What kind of palette do you recommend?*

A big, white palette with deep wells around the perimeter, a large mixing area in the center and a cover to keep paints clean when not in use. Little palettes have too few wells and not enough room to mix. A large mixing area can be an unexpected teacher: When paints run together, you discover new color mixtures. When you finish for the day, cover your palette to keep your paints clean. Next time, moisten them with a little spritz of water, squeeze fresh paint out if you need to and you are ready to go.

> *Should I put my colors in a certain arrangement on my palette?*

A good arrangement is to place warm colors (reds, oranges, yellows) on one side and cools (greens, blues, violets) on the other, in color-wheel order (see page 47). If you have extra wells, you can add new colors later. With a black laundry marker, write each color's name on the palette's side, under the well in which you will always place it. Then use the mixing area closer to your warm colors for warm color mixtures, such as warm grays. The mixing area closer to your cool colors is for cool color mixtures, such as cool grays.

When you begin painting, it's a good idea to have all your colors out—not just the colors you think you are going to need. After a while, you learn every color on your palette by always having it there, in the same place. You soon reach for your colors without even thinking. You are just painting.

BEST PALETTE

The palette below has a large mixing area, and each well can store an entire 15ml tube of paint. That's good! It comes with a cover to keep your paints clean.

It's a good idea to keep your cool colors on one side and your warm colors on the other. Empty wells between the Winsor colors and their neighbors are because the Winsor colors are staining colors (see page 41). Keep them separate from other colors. For example, you do not want to accidentally pick up some Winsor Green on your brush and contaminate another well of color, such as Jaune Brillant #1 or Aureolin. Take a black laundry-marker pen and label your colors on the side of your palette, as seen here.

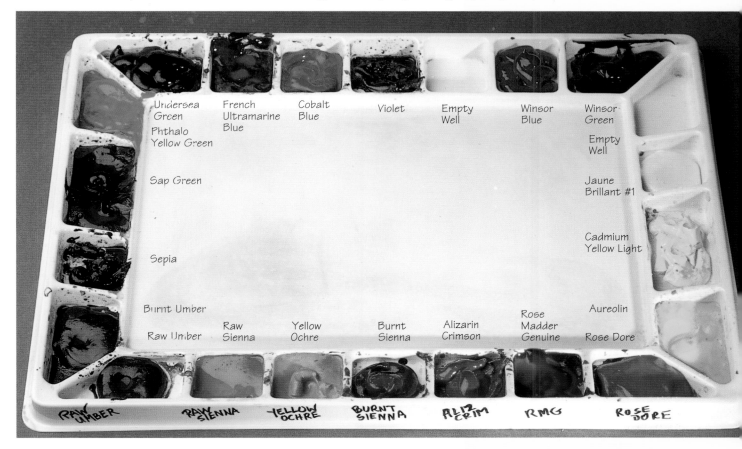

Remember—there are no rules...

How much paint should I squeeze out on my palette?
As a rule, you want about half of a 15ml (large) tube in each well. If you have very little color out, your paintings will look pale and washed out because the paint is still in the tubes, not on your palette or on your paper.

If I squeeze half a tube of paint in each well but do not use it that day, do I have to throw it away?
Do not throw your paints away after every use, as it would indeed get extremely costly. Just wipe your mixing area when finished or when you need the space to mix something else. If you have not finished your painting, you could leave the colors in the mixing tray and cover them until the next time. Then just spritz them with water when you start up again, and you have the same colors you had yesterday or last week. If you continue that one painting, all your colors for that painting will be ready to go.

How long will paints last on my palette, and how can I make sure they last as long as possible? Do some colors last longer than others?
Most paints can last for years on your palette if you use them regularly and have a cover to protect them from dirt. Just spritz a little water on them with a spray bottle to wet them again, and add a little fresh paint if they have been sitting for a while. If you only paint twice a year, however, you may find that all the paints on your palette become wasted and cracked because you have not used them. When you paint often, they stay more moist because you keep wetting them.

Some colors do not last long on the palette no matter what. They crack and become useless. Is it only certain colors?
There are some particular colors that do not even last overnight. For example, Sepia will crack by the next morning. Certain colors in different brands will crack eventually. You will learn over time what colors are that way. Just do not squeeze large amounts of those paints onto your palette. In any case, if your paints are dry and crumbled, you will need to scrape them out of the well and squeeze in some new paint.

I have discovered a new brand of paints made with pure honey, gum arabic and pigments, by M. Graham & Co. None of the paints crack! Honey contributes moistness, fluidity, increased pigment concentrations and freedom from reliance on preservatives.

I bought a new palette with a lid and my watercolors were dry the next time I used them. Is this normal?
It may be that you are not putting enough paint in each well. If you put paint the size of a pea in each well, it will dry up and fall right off the palette. You need to put a great deal of paint in the wells—at least half of a 15ml tube—so you can swish your brush around in the paints the next time you use them. They will still dry out (like watercolors that come in cakes), but if you spritz them with water or add fresh paint, they will come alive again and not fall off your palette.

If the cap on my tube of watercolor does not want to come off, how do I get it open?

There are several things you can do. You can take a lighter or match and hold it under the lid to soften it (fifteen seconds). When you go to twist it off, use a paper towel or rag; you have just heated up plastic and it's hot! You can also unroll the bottom and squeeze the paint out that way, or just cut the tube with scissors if neither of the above work.

If my paint has dried up in the tube, can I use it like a cake watercolor?

Yes. You can saw it open. It's like a cake of watercolor, so just moisten it.

What causes the granular appearance of some colors when applied to the paper's surface?

Some pigments are sedimentary. They separate and float on the paper's surface rather than soak into it. The granules settle in the texture, or tooth, of the paper, giving it a textural look. See below for the beautiful effect Judith Klausenstock achieved with sedimentary colors in *Cherry Jam*. Sedimentary colors include Cerulean Blue, French Ultramarine Blue, Manganese Blue, Burnt Umber, Burnt Sienna and Yellow Ochre.

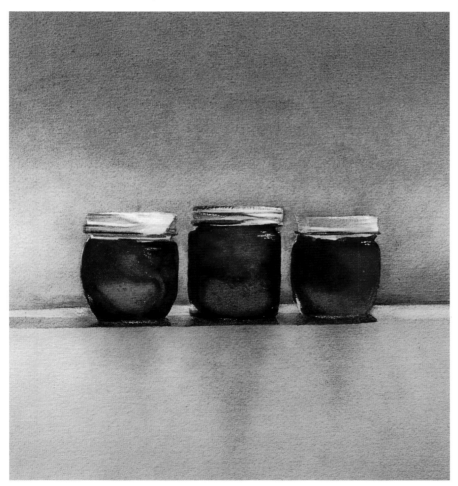

CHERRY JAM
by Judith Klausenstock
13" × 15" (33cm × 38.1cm)
Watercolor on 140-lb. (300gsm) cold-pressed paper
Private collection
Photo by artist

IT'S A PROCESS

Painting is so much more than sitting down and doing a painting. For me, it has been much deeper. A journey. It's been a lifelong process, risking one thing after another to make your dream come true. The risk involved to become a full-time artist has led me to the highest form of meditation and prayer I have ever felt while painting. Once you experience this safe and peaceful place, you will not be able to stay away from your art. All the sacrifices and no's you said to parties, television, phone calls and people, so you could paint, will give you so much courage and faith. Try it for yourself.

Remember—there are no rules...

RESPECT YOUR OWN TIME

When you treat your art and time with respect, people will understand that they must not bother you while you are painting. Period! All you need to do is tell them that. People who have boundaries themselves will respect yours. There will be others who will push you, testing your boundaries until you really get tough. These people are gifts in your life to teach you these boundaries and make you stronger. Taking time out for yourself does get easier the more you practice. When you see what you can accomplish when you say no, you will not feel so selfish. You will soon learn how easy it really is to say no without explanation or guilt. It will become second nature to you. If you work in an office, would you let someone come sit on your desk and yak for hours? Certainly not. Would you have a problem telling them no? Same thing.

What is transparent watercolor, and why is it so important? How can I tell which paints are transparent and which are not?

When something is transparent, you can see through it. The beauty of transparent watercolor is that it creates a glow you cannot get any other way, caused by the white of the paper shining through transparent color and making that color sing. *Bare Trees* (pages 32-33) is an example of a transparent watercolor.

It takes practice to learn which paints are more or less transparent, as well as how much water and paint to mix for brilliant transparent colors on your paper. If the effect you get is not transparent, either your mixture is too thick or you are using an opaque color. Color charts such as those shown here can help you tell which paints are transparent and which are not. Most of the colors on my palette are transparent.

What is opaque watercolor?

Opaque watercolors are the opposite of transparent watercolors. You cannot see through opaque watercolors as well as you can through transparent watercolors. Though most watercolors are transparent, there are a few opaque ones you may want to use, particularly if you want to hide or highlight something. You can mix transparent and opaque watercolors together. There are no rules!

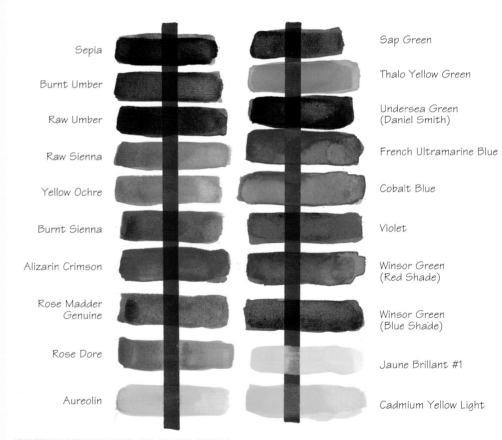

Sepia · Burnt Umber · Raw Umber · Raw Sienna · Yellow Ochre · Burnt Sienna · Alizarin Crimson · Rose Madder Genuine · Rose Dore · Aureolin

Sap Green · Thalo Yellow Green · Undersea Green (Daniel Smith) · French Ultramarine Blue · Cobalt Blue · Violet · Winsor Green (Red Shade) · Winsor Green (Blue Shade) · Jaune Brillant #1 · Cadmium Yellow Light

IDENTIFYING TRANSPARENT AND OPAQUE COLORS

Take a felt-tip marker and draw a fairly thick line or two down your page. Paint the color over the line. If you cannot see the color over the black line, it is transparent. If you can see the color, it is more opaque. Notice how Jaune Brillant #1 is more opaque than the other colors. These are the same colors you see on my palette, most of which are transparent.

⁊❧ *What is a staining color?*

A staining color is a color that will not lift off your paper as easily as a nonstaining color. No matter how hard you lift or scrub, it leaves a hint of pigment on the paper. Though they are wonderful, Winsor and Thalo colors (such as Winsor Green and Thalo Green) are staining colors that easily overpower other colors in a mixture. Use caution in the beginning until you understand their strength. Manufacturers' color charts often tell you if a color is staining or not.

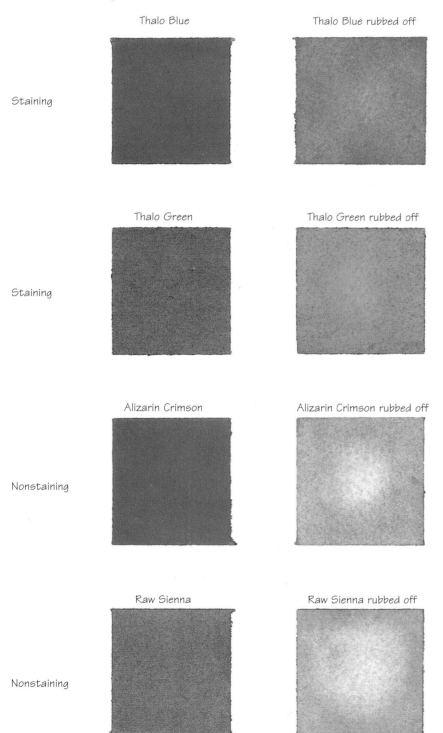

Thalo Blue Thalo Blue rubbed off

Staining

Thalo Green Thalo Green rubbed off

Staining

Alizarin Crimson Alizarin Crimson rubbed off

Nonstaining

Raw Sienna Raw Sienna rubbed off

Nonstaining

STAINING AND NONSTAINING COLORS

Staining colors will not lift off your paper as readily as nonstaining colors. They stain your paper in the same way some chemicals or foods stain your clothes in that the stain never completely comes out, no matter how hard you scrub. Same with certain pigments on certain paper. Some papers have a better lifting capacity than others, but staining colors will stain no matter what. Manufacturers' color charts often list whether a color is a staining color or not. But do not think you should not use these colors because would stain your painting; these colors are absolutely gorgeous! They are usually the Winsor and Thalo colors.

The left column here shows colors mixed with very little water, almost right out of the tube. The same colors are in the right column, but there I tried lifting off color in each square with an oil bristle brush. Thalo Blue and Thalo Green, at the top, are staining colors. The bottom two are nonstaining colors, Alizarin Crimson and Raw Sienna. See how much more color stays on the paper with the staining colors?

JUST SAY THANKS

When others compliment you on a painting, just say, "Thank you." I used to tell them everything that was wrong with it, until someone gave me this advice: Just say, "Thank you." At first, it was hard to get those two words out of my mouth, but I practiced. I did not believe my admirers. My mind was saying, "Surely they don't mean it. They're just being nice." It took many years for my mouth and heart to connect. Today they connect, and I really mean it when I say, "Thank you." My heart feels it too. Say it with pride!

Remember—there are no rules...

🦢 *What does "lightfast" mean?*

If a color is lightfast, it's resistant to fading with exposure to light. This is a major concern with watercolor, since certain impermanent colors fade more easily than others. It's so important to work with colors that will not fade in a month or two. Make sure a color is lightfast before you buy it, no matter how pretty the color is. Each tube of paint you buy should have an ASTM (American Society for Testing and Materials) permanency rating on its label. An ASTM lightfast rating of I means excellent lightfastness. An ASTM II rating means very good lightfastness, and on down the line. Avoid paints that do not have good lightfastness; search for more permanent pigments.

🦢 *Are watercolors toxic?*

Some are; some are not. If a paint is toxic, there should be information printed on the label to that effect, as well as a statement of certification by the Art and Craft Materials Institute (ACMI). If the product is nontoxic, it should carry the seal of the ACMI.

🦢 *Can you recommend a good reference book about the qualities of different watercolor paints?*

I would strongly recommend *The Wilcox Guide to the Best Watercolor Paints* by Michael Wilcox (Perth, Western Australia: Artways, 1991). It's extremely handy and user-friendly, with everything you have always wanted to know about paints. It tells the makeup of pigments, with all the brands. It rates each brand and color based on lightfastness and health information. Do you want to know whether a particular color in a brand of paint will fade in a month, or whether it's toxic? You can either do your own tests or find the answers in this book.

🦢 *What does "water-soluble" mean?*

Water-soluble art mediums can be dissolved by and mixed with water. They include watercolors (in tubes or cakes), gouache, inks, acrylics, water-soluble crayons, water-soluble oil paints and egg tempera.

WATER-SOLUBLE MEDIUMS

Can I put acrylic paints or other mediums on top of watercolor paints?
Yes, though acrylics have a different consistency that does not "push around" as easily as watercolors. I painted *In a Sacred Manner We Live* with both watercolor and acrylic. You can also try putting different mediums in with or on top of your watercolor, but make sure they are water-soluble and won't crack in a year or two.

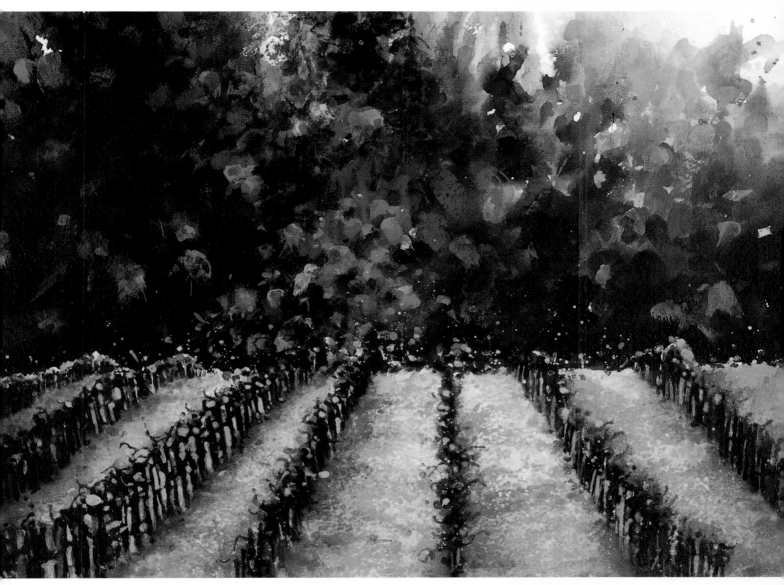

ACRYLICS HAVE COVERING POWER

As I was doing this painting, I wanted to break up some of the darker shapes in the background trees. But it's difficult to put a lighter watercolor over a darker one unless the lighter color is opaque. Acrylics have more covering power than lighter watercolors, so I went for it and it worked!

IN A SACRED MANNER WE LIVE
Watercolor with acrylic on 300-lb. (640gsm)
Lana hot-pressed paper
11″×14″ (27.9cm×35.6cm)
Private collection
Photo by Ron Zak

MIRACLE OF THE HUNDRED GLAZES

Once I was preparing for an art festival. *Sentient Beings* was to be my star piece. It must have had fifty glazes on it. Planning to finish it the next day, I set it down to my right and worked on something else. Well, I have a habit of flipping water or paint out of my brush onto the floor. A big spot of Sap Green landed on my painting, in the middle of the sky. The next few weeks, I put down wash after wash hoping if I put enough down the spot would disappear. It finally did. I stepped back, and the glow in the painting was unbelievable! Peeling the masking off the cows, I could not believe what I had done. All I did was fall in love with my own process through a mistake I made.

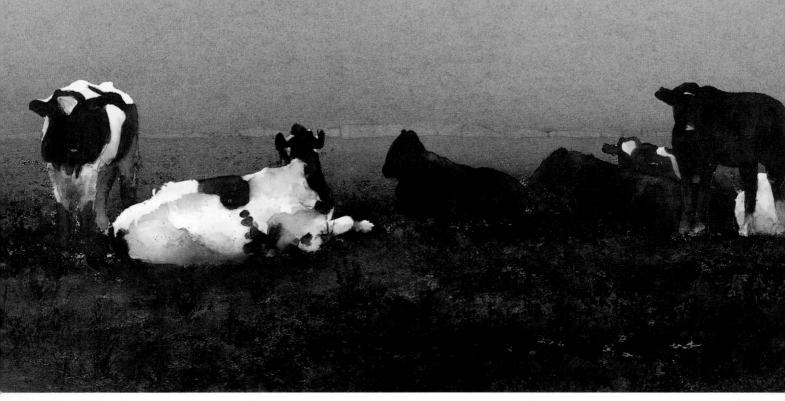

SENTIENT BEINGS
Watercolor on 300-lb. (640gsm) Lana hot-pressed paper
21″ × 29″ (53.3cm × 73.7cm)
Private collection
Photo by Ron Zak

Combining Colors, Water, Paper and Brushes

Artists trying to paint realistically often experience a basic problem in choosing colors: What our eyes actually see and what our minds think we should see are different. Many beginners do not paint what they *see*, but what they think they *should paint*. Get your mind out of the way. Record what you *see*.

For example, study a simple red apple. Your mind tells you it's red. Do you *see* other colors in it, such as yellows or greens?

The next time you are outside, look at some distant trees. Do they appear as green as the tree next to you? Are they more blue, or more purple? Do you see every leaf? Your mind tells you they are trees, so they must be green and have leaves on them. Therefore, you may want to paint every leaf. Yet you do not necessarily *see* those leaves from a distance. You *see* color and shapes.

Retrain your eyes and your mind to *see* as well as think. In the process of learning to paint, you will begin to see color in a different light because you will be more observant.

BE PREPARED

Have everything you need out and within reach before you begin painting. There is nothing more frustrating than stopping the flow of your painting to get more water, or to look for a tube of paint, some paper towels, a brush. If you have two water tubs instead of one, you will not have to get clean water as often.

How should I mix my water and paint in order to keep the pure colors in the wells of the palette as clean as possible?

Find a couple of sturdy plastic buckets for your water. Tall yogurt containers will do. First, wet your brush in your water, take a little paint out of the well with your brush and place that paint on the palette right next to the well of color you are using. Rinse your brush until it's clean. Do the same with the next color you need. You keep your paint clean by taking your paint from the little patches of color on the palette, not from the well. When you need more color, clean your brush thoroughly with water and dip into another color. You want to keep your paints as clean as possible. Mix them in the mixing area of your palette, not in the wells.

How do I know what colors to mix together to get the results I want? Can you suggest some basic exercises to help me begin to learn about color mixing?

For starters, you need to know that the primary colors are red, yellow and blue. Theoretically, you can use these three colors to mix all the other colors. Make a simple color wheel, as shown here, using the three primary colors to mix the three secondary colors (orange, green and purple). Keep this color wheel next to you in your studio or working area to serve as a reference guide for mixing colors until you become familiar with them. Once you learn to mix secondary colors from primaries, you can make your orange a little brighter by adding more yellow, your purple more reddish with more red and so forth. It's best to mix darker colors a pinch at a time into lighter colors so you do not end up with lots of unwanted paint on your palette. For example, it takes far more yellow than blue to get green. So it's easier to add a touch of blue to yellow rather than trying to make green by adding lots of yellow to a dark blue.

Make a Simple Color Wheel

1 PAINTING IN THE PRIMARY COLORS TO MAKE A COLOR WHEEL

You must have three colors to do this exercise: red, yellow and blue. You can use the colors I suggest in this book, such as Alizarin Crimson, Aureolin and French Ultramarine Blue, or, if you already have your own, use them. Draw six circles as shown, each about 1½ inches (3.8cm) in diameter. Begin by mixing yellow (Aureolin) with a little water in your mixing area, and fill in the circle at the top of your wheel. Clean the brush with water. Mix blue (French Ultramarine Blue) with a little water, skip a circle and paint your blue in the next one. Rinse your brush every time you plan to use another color. Take your red (Alizarin Crimson), mix with water, skip a circle and fill in the next one.

WHAT YOU NEED

- Watercolor paper
- Pencil
- Palette with wells and mixing areas
- Paints in primary colors:
 red (such as Alizarin Crimson)
 yellow (such as Aureolin)
 blue (such as French Ultramarine Blue)
- Water
- Brush of your choice

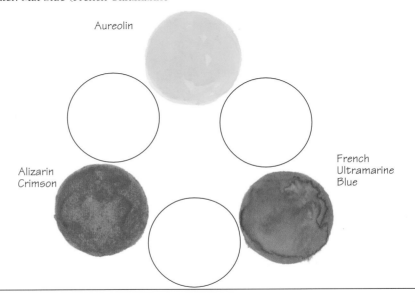

Aureolin

Alizarin Crimson

French Ultramarine Blue

❷ MIXING PRIMARIES TO CREATE YOUR SECONDARY COLORS

To make orange, scoop a little Aureolin out of its palette well with your brush, and place it in a mixing area. Rinse the brush thoroughly. Again with your brush, place Alizarin Crimson out on your palette. Because red is darker than yellow, add the red a little at a time into your yellow, until you get an orange you like. Paint in the circle between Aureolin and the Alizarin Crimson. You may want to test it on another scrap piece of paper to see if it's the orange color you want. It's different on the brush than on the paper.

To get purple, make sure your brush is clean, then scoop out a little French Ultramarine Blue and place it on another mixing area on your palette. You should already have a patch of Alizarin Crimson out on your palette. Remember, the red is darker than the blue, so mix the red carefully into your blue.

For your green, slowly add French Ultramarine Blue into Aureolin in another mixing area. Slowly adding a dark color into a light color is usually a safe bet. Light colors into dark are more difficult to mix because it takes a lot of paint to get a darker color lighter; it can often be a waste of paint and time. After all that, you might even end up with a just a pile of mud. You have now completed the basic color wheel. When you are painting, keep it at your side and use it as a reference guide. Theoretically, with these three colors (red, yellow and blue) you can make any color. Mixing colors does become more complex, but this is basic information you need to know now.

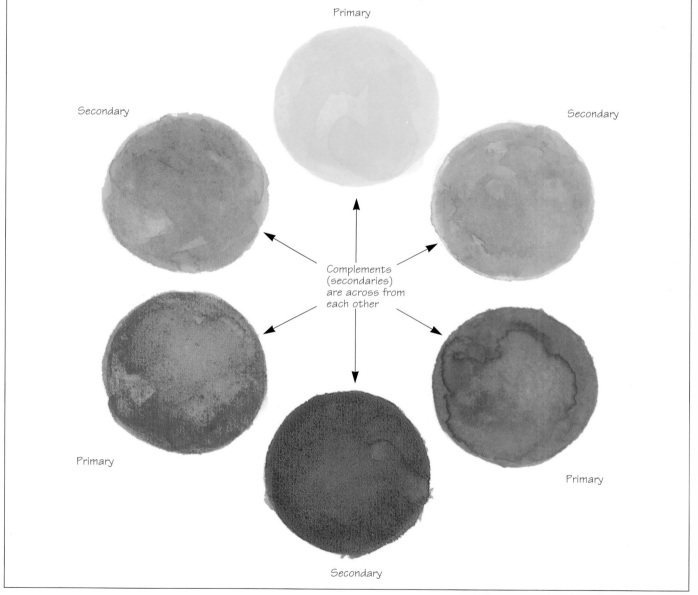

Primary

Secondary

Secondary

Complements
(secondaries)
are across from
each other

Primary

Primary

Secondary

🖎 What are complementary colors?

Complementary colors (secondary colors) are directly across from one another on the color wheel, such as red (perhaps Alizarin Crimson) and green (such as Sap Green or the green mixed in the color wheel above). Other complements include blue and orange, yellow and violet.

LUNCHEON IN PARIS
Anne Adams Robertson Massie
Watercolor on 140-lb. (300gsm)
Fabriano Artistico Paper
21″ × 29″ (53.3cm × 73.7cm)
Collection of the artist Photo by Robert DeVaul

SHUT OUT GUILT

Don't allow guilt in the studio, or wherever you choose to paint.

~ Why should I know about complementary colors? How can they help me in my paintings?

For one thing, you can use complements next to each other for emphasis in a painting. For example, if you want to make something red in your painting stand out, stick a green right smack next to it and watch them sing! See Anne Adams Robertson Massie's watercolor *Luncheon in Paris* (at left) and how she uses complements, as well as various warm colors next to cool colors. She is a master at this. Begin looking at color in paintings. You will see how artists place complementary colors either next to or close by each other to make the painting successful.

TAOS
Watercolor on 300-lb. (640gsm)
rough paper 21″ × 29″ (53.3cm × 73.7cm)
Private collection
Photo by Ron Zak

COMPLEMENTS IN NATURE

You will notice complementary colors in nature. Notice the walls of the pueblo, made from the earth (an orangy brown), and how they complement the blue sky. In *Taos* I painted the entire painting first. Then I glazed over the shadow areas with thin washes (see page 58 for a definition of washes and glazes) of Burnt Sienna and French Ultramarine Blue—complements. As a result, the darkness is translucent.

Why are my colors so pale? What can I do to make them look brighter?
You are probably not using enough paint. Squeeze at least half of a 15ml tube of paint into each well.

If you want to learn to paint, you must focus on the painting, not how much a tube of paint costs or anything else. It's part of the process we all go through as artists. You have to clear your mind of many monsters in order to paint. This is one of them.

You cannot make a rich, luminous watercolor painting if your colors are still in the tubes. They must be out on your palette. All of them!

Squeeze out those paints! The time has come. Make that painting!

Many different workshop instructors have recommended many different color palettes to me. One instructor recommends a particular set of colors, then another teacher says the ones I just bought are all wrong. What should I do?
You have to take what you want from each workshop, but then paint for yourself. Discover for yourself the colors you do and do not like. You may buy all sorts of colors when you are just beginning, particularly if an instructor recommends them. After you have been painting a while, you will find that you use only certain colors over and over again. Those colors will become your palette.

PAINT EVERY DAY

Get into the habit of painting every day, feeling good about yourself and getting some paintings done!

BOUGAINVILLEA
Watercolor on 300-lb. (640gsm)
Lana hot-pressed paper
21" × 29" (53.3cm × 73.7cm)
Private collection
Photo by Ron Zak

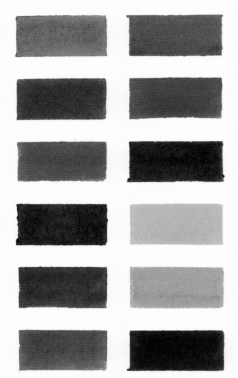

MIXING COMPLEMENTS

Here I have taken two complementary colors from my palette, Sap Green and Alizarin Crimson. I have mixed them with various amounts of water, some with more green into a mixture of red, some with more red into the mixture of green.

What about mixing complementary colors?

One of the ways to tone down a too-bright color is by adding its complementary color to it. This is what "graying down" means—calming the color down without deadening it. See how many colors you can get by mixing different proportions of two complements, adding different amounts of water to them. This exercise can help you learn to make more interesting colors. Mix each pair of complements on separate charts. Add more water to each mixture as you go across the row.

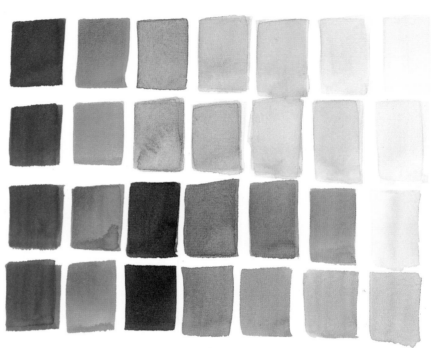

BLUES AND ORANGES

Take one blue at a time and mix it with some of your warmer, more orange colors. The top row here is French Ultramarine Blue and Raw Sienna (not really orange, but warm). Add water to that mixture (making it lighter), put it down and continue across to see how many grays you can make, adding more and more water into each mixture as you go.

The second row is a mixture of French Ultramarine Blue and Yellow Ochre. Add water as you go across. The third row is mixtures of French Ultramarine Blue and Burnt Sienna. Add a little more of the Burnt Sienna until you get a brown. In the bottom row, mix French Ultramarine Blue with Burnt Sienna, adding more blue to this mixture until you get a very deep gray brown.

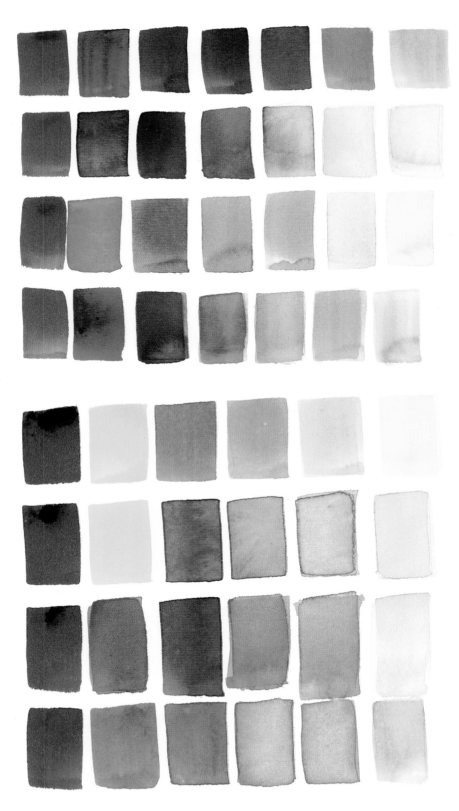

REDS AND GREENS

Pick one red and mix it with all of your greens, trying to get neutral colors before adding water. The top row is Alizarin Crimson and Sap Green, adding more and more water across the page. The second row is this process repeated with Alizarin Crimson and Undersea Green (Daniel Smith). Next, Alizarin Crimson mixed with Thalo Yellow Green. The bottom row is violets made by mixing Alizarin Crimson and Winsor Green (Blue Shade). Gorgeous!

VIOLETS AND YELLOWS

Take one violet and mix it with all your yellows. The top row is Carbazole Violet (Daniel Smith) mixed with Cadmium Yellow. The second row is the same violet mixed with Aureolin. The third row is violet and Raw Sienna. The bottom row is violet and Yellow Ochre.

MIXING TWO DIFFERENT BLACKS

You can mix black if you do not have a tube of black. It can also make your painting more interesting if you mix your own. In both mixtures shown below, if you want the black to be warmer, then you add more of your warmer color. Alizarin Crimson and Van Dyke Brown are the warm colors here. If you want your blacks on the cooler side, add more of your cooler colors (Winsor Green and Payne's Gray).

Alizarin Crimson + Winsor Green = black

Van Dyke Brown + Payne's Gray = black

MUD ALERT!

🎨 *I hear that it is not good to have black paint on my palette, but that I should instead make blacks by mixing other colors together. Why?*

First of all, you can put whatever color you want on your palette. No rules, remember? However, you can deaden a painting with black very easily. When you are not sure how to mix colors, you may want to use black for darkening everything. This can leave your painting with a flat, uninteresting look. I did the same thing. It seemed logical.

Knowing how to make blacks by mixing colors, as shown at left, will help make your painting richer. You can have black on your palette if you want. There are no rules! However, now if you do not have black around, you will know how to get it.

🎨 *Can you recommend a good black?*

Lamp Black is opaque and on the cool side. It has a flat (lusterless) look to it. Ivory Black is semi-opaque and warmer than Lamp Black, with a tint of brown.

COOLER AND WARMER BLACKS
Lamp Black is opaque, flat and on the cooler side. Ivory Black is semi-opaque and warmer, with a tint of brown.

Lamp Black Ivory Black

🎨 *I heard in a workshop that I should use the white of the paper as my white in a watercolor, not the white watercolors I have seen in tubes. Is this true? How do I go about using the white of my paper in my paintings?*

Using the white of your paper as opposed to white paint is up to you. Yet one of the beauties and challenges of watercolor is to leave areas of blank paper as whites, as well as letting white paper glow through transparent pigment, creating the effect of light. Just remember, once you paint over that little speck of white paper that you wanted to leave, it's gone, along with all the freshness and liveliness of that highlight. To save the white of your paper in watercolor, you must plan light areas before beginning and mask them (see page 54) or learn to leave them alone. Thelma Cornell Spain chose the latter for her watercolor *Cape Mystic*. Thelma explains, "In my first several washes I think light. After those first washes, I become bold and assertive as I continue to develop expressive brushstrokes. There are

both hard edges and soft edges used to enhance both lights and darks throughout the painting."

You can also use white watercolors out of the tube, if you want to, for your whites and add them to your other colors to either make them lighter or more opaque. However, keep in mind that white watercolor is opaque; it can muddy up a watercolor painting. White gouache or white acrylic are other mediums to try for your whites. Experiment carefully with these.

BE A STORYTELLER

Thelma Cornell Spain expresses, "*Cape Mystic* is both mysterious and spiritual. White light and lush color create a fascinating mood. I love the atmospheric effects that surround the sea and shore. The small lighthouse speaks of how all buildings compare to the grand expanse of our land and water. Break the rules of the road! Pretend you are Columbus discovering a new world! Be a storyteller—not a reporter."

HARD AND SOFT EDGES

Hard edges are sharp lines, often defining form, that do not blend into adjacent areas. Soft edges may also define form, but they have limits with no definite line, allowing a value or color to blend into adjacent areas.

Remember—there are no rules...

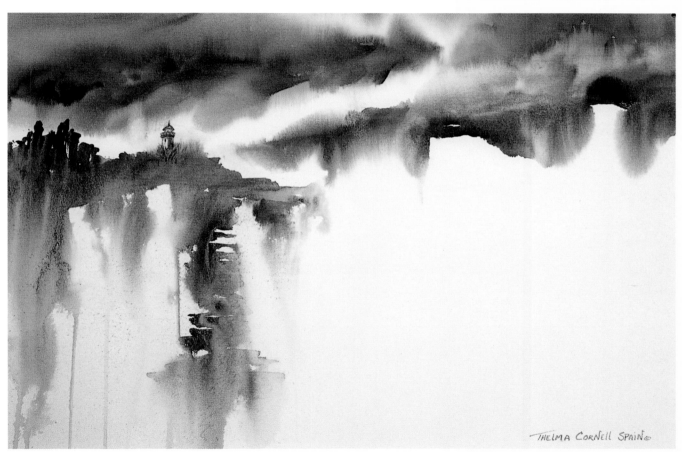

CAPE MYSTIC
Thelma Cornell Spain
Watercolor on Crescent board
19" × 25" (48.3cm × 63.5cm)
Collection of the artist

Remember—there are no rules...

🔊 *What is masking fluid?*

Masking fluid is a liquid resist you can use to preserve the white of your paper. In watercolor painting, you need to plan ahead if you want the white of your paper to be the white in your painting. At the end of an oil or acrylic painting, you can hit it with all the white you want and you have your highlights. In pure watercolor painting, the white of the paper is your white, so planning for its placement well ahead of time is important.

After you determine where your whites are going to be, paint the masking fluid on these areas with a no. 2 or no. 3 synthetic brush with a good tip. Be precise—there is an art to using this product. There are several different brands. I use gray masking fluid, which is a neutral color that does not throw my eye off or interfere with the other colors in my painting while I am working. Some masking fluids are neon colored. They do interfere with the way you see the other colors in your painting. I can't even see the white masking fluid.

When your masking fluid is dry, you can paint without restrictions. Let it dry naturally and never in the sun as it will bake into your painting. Before you remove the masking fluid to work on your white, make sure your paper is thoroughly dry, then peel off with your clean fingers.

Masking

WHAT YOU NEED

- Watercolor paper
- Palette
- Paints in colors of your choice
- Masking fluid
- Masking brush
- Wash brush
- Brushes for details
- Water
- Drop of dish soap

❶ MASK THE COWS

First, dip your masking brush in a soapy water mixture. Squeeze as much liquid out of the brush as you can, but keep it moist. Then dip it in the masking fluid. Never dip a dry brush in your masking fluid. It gums up immediately. Paint in cows with masking fluid. Be precise about where you put the masking fluid. Do not apply it haphazardly. Let it dry thoroughly until not tacky when touched with your finger.

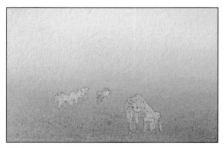

❷ WASH IN BACKGROUND

Now paint in your background right over the masking fluid. Here, I have laid down several graded washes.

❸ PEEL OFF MASKING

When your paper is completely dry throughout, gently remove masking by peeling it off with clean fingers.

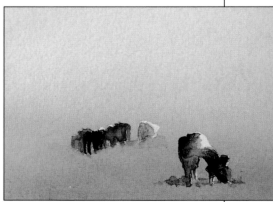

❹ FINISH WITH DETAILS

Go in and work on the detail. You're finished!

🙿 *Can I use masking fluid to make reflections on glass?*
See *Isn't Life Grand?* at right. All I did in this olive oil bottle was to mask out some white reflections I wanted to save and also the lights where the lemons reflected onto the bottle.

🙿 *Sometimes when I mask something and then peel it off, some paint has seeped under the masking fluid or it didn't cover in certain areas. Is this normal?*
This should not happen if you apply masking fluid correctly. Be careful and make sure you have it on evenly and exactly where you want it. At times, it appears it is on evenly, but, as you can see below, it is not. In this case it is thinner in some areas and thicker in others. You should also know that shaking a bottle of masking fluid puts air bubbles into the emulsion that will later break, producing pinholes where paint can leak through to your paper. If you must, stir your masking fluid—don't shake. You might want to test your masking material on a scrap piece of the same kind of paper you are using for your painting just to be sure it will work as you want it to.

Isn't Life Grand?
Watercolor with black gesso on 300-lb. (640gsm)
Lana hot-pressed paper
11" × 15" (27.9cm × 38.1cm)
Private collection
Photo by Ron Zak

Some places where paint has seeped under masking fluid.

DON'T DO THIS
This is a masking problem. This masking has been applied with no thought—very haphazardly. It is thin in some spots and thicker in others. It is unevenly applied, and some of the paint has seeped under the masking. Masking is an art, and you have to think about the results you want to achieve before applying it. Be very careful when masking. Have a plan.

🐦 *What is wet-in-wet?*

Wet-in-wet is a technique. First you wet your paper, either with water or color, and then go in and work on the painting while it's still wet. You are in control, because you're manipulating the paint, but out of control at the same time, because the paint makes its own patterns with this technique.

Begin by wetting your entire paper with clear water (or paint) with a wide wash brush, leaving an even sheen on the paper. You do not want it to be sopping. Start dropping colors on the wet paper, and watch them flow all over. Let some areas dry a little, and then go back in with more water or paint. This will give you more shapes to work with and make the painting much more exciting.

You can either have a plan or not. This is a tricky technique, but so many exciting surprises happen. Paying attention to where it is taking you is the key.

It only takes seconds to cause "oozels" as I call them, or blossoms when working wet-in-wet. Sometimes you want them, and other times you do not. After a while, you will learn how to work the blossoms into your paintings, if you want to. Experiment with many degrees of wetness. You will also learn when to leave it alone and stop.

WET-IN-WET TECHNIQUE

In this painting, Thelma used a wet-in-wet technique to get these exciting shapes. This technique just flows, and if you flow with it, you can create many unusual shapes.

NORTHERN EXPOSURE
Thelma Cornell Spain
Watercolor on Crescent board
5¼" × 8" (13.3cm × 20.3cm)
Collection of the artist

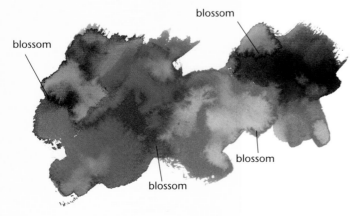

blossom
blossom
blossom
blossom
blossom

BLOSSOMS, OR "OOZELS"

These patterns occur when you work on one portion of your painting and it is not quite dry when you paint another color or area next to it. This second area of paint will spread into the first, causing blossoms. If you do not want them, you must work quickly when you blend and have patience before the next color goes on. Let the first color dry before applying the next. I find blossoms interesting now and have learned to work them into my landscapes when they occur.

How can I create soft edges to give my paintings, particularly my flower pieces, that soft watercolor look?

While the paint is still wet, lightly spritz parts of the painting with water from a spray bottle.

When I mix color on my palette it looks right, but when I put it on the paper, it is completely different. Is this normal?

What I would suggest is that you have a test sheet of paper next to your painting (a small scrap of watercolor paper works). You are right. The colors look different once you lay them down on your paper. After you have mixed the color on your palette, you can test it on the scrap paper to make sure you like how it will look. Then put it down on your painting. Or, you may have old paint in the brush that you can not see, so testing is good.

When my paint is wet, the colors are so luminous and rich. When they dry, the colors are dull. Is this normal?

Yes. When paint dries in watercolor, it is always lighter. You will learn how much pigment to use on your paper with practice. If your painting is too light, you can go over it again with another layer of paint (as if you were painting it again), making it darker. Layers add great interest, particularly with many different brushstrokes on top of one another. In the beginning, you may be so afraid of making a mistake when you put your paint on the paper, you can barely see your painting when it dries. This is very common.

What I do is find an old mat, put it around the dry painting and then place a piece of clean Plexiglas over it. This brings up the luminosity of the colors I saw when it was wet, and it also shows how it will look framed (which always brings up the color more).

SET BOUNDARIES

Boundaries are number one on the list of things you need to learn in order to be an artist. Learn how to say no. If you want to get some painting done, you are going to have to learn this ever-so-short sentence. Yes, I know you are having a ball, but you are still working. Ever get angry at your friends for calling and bothering you while you are painting? "Why do they do this? Can't they see I'm working!" You get so angry at *them*, not you. Guess what? It's not their fault. Don't be upset with them. They bother you because you are letting them. You are answering the door, the phone. Remember, "No" is a complete sentence! And if you are serious, you will be saying no to just about everything (or so it will seem). You practice it like everything else. Don't worry; it gets easier.

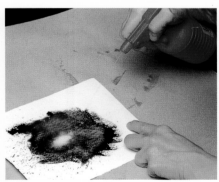

DON'T DO THIS
This is what happens when you spray full force onto your wet paint. The force of the spray leaves no design, and you end up spraying all the color off the paper. Only spritz "drops" of water. You will only get soft edges by using very little water.

CREATING SOFTER EDGES
First paint in your flower or foliage, leaving some white areas throughout. While still wet, give it a tiny spritz of water, pushing the paint with your water bottle away from the flower. Some of the water will run into those white areas, giving it more interest. Leave those white areas, or you will have one big blob.

JUST PAINT

Don't get too attached to the outcome of your painting—how much money you will make from it or whether any shows will accept it. No other thoughts or worries should be on that painting when you are creating it. You should just be painting.

𝕭 *What is a wash? What is a glaze? What is the difference between them, if there is one?*

A wash is a thin, liquid layer of transparent paint applied with a wide wash brush. Glazing is the technique of building up transparent washes one color at a time, letting each layer dry in between and allowing underlying layers to show through later glazes. A glaze is not something you buy in a bottle and put on your watercolor. Glazes are layers of transparent watercolor washes.

It takes time to build up glazes one by one to achieve the effects you want, but it's very exciting. For instance, you might want a violet color for a moody painting. Instead of mixing on your palette, you might put a wash of Rose Madder Genuine over the paper, let it dry, then put down a wash of French Ultramarine Blue. You can go on and on, glazing with many colors, letting each layer dry in between, until you achieve the desired glow or effect you are after. Another approach is to mix Rose Madder Genuine and French Ultramarine Blue on your palette, then apply the wash, which looks different from the glazing technique.

𝕭 *Should I mix washes on my palette? If not, what should I use for mixing my washes?*

You can mix washes on your palette. Yet, since you may often want to use a good deal of wash to cover large areas of a painting, a larger mixing area is often better. If you need to mix your paints in large batches, you may never seem to have enough if you mix on the palette, and when you mix another batch of a color, it might not match the first batch.

To make sure you have enough of the mixtures you need when you need them, I would suggest using white plastic party plates. I use the large dinner plate size, but there is also a smaller size that I have seen used for smaller washes. If you still run out of a color and can't seem to match the mixture perfectly, just try to get it as close as you can.

MIXING ON PLATES

I mix washes in white plastic party plates from a party store (foam plates do not work as well). Get white so you can see what you are mixing. Mix washes thoroughly on the plates with an old round brush, not your best wash brush. When mixed thoroughly in the plate, dip your wash brush into the mixture and begin washing. Consider leaving an old brush in each plate until the end of your painting session. That way, each time you want to mix, you do not have to rinse a brush until the end of your painting time.

✒ Are there certain wash brushes that you recommend, and why are some better than others?

If you want smooth washes, it is extremely important that you do not skimp on a wash brush. Some really horrible wash brushes out there look exactly like the expensive ones but are worthless. The hairs fall out in no time. The cheaper brushes will never give you smooth washes. I have seen the struggles my students have gone through with these less-expensive ones. Spend the extra money. Invest in a good one, and you will never be sorry.

Wider brushes give the best coverage and smoothest washes when you're working big, on a 22″×30″ (55.9cm×76.2cm) full sheet of water-color paper. My favorite is a Holbein 4¾-inch (12.1cm) hake (pronounced hockey) brush. This brush holds a great deal of water, which is important. If you apply your washes thinly and correctly, the wider brush is less likely to leave streaks on the paper. I have even used 6-inch (15.2cm) and 7-inch (17.8cm) hake brushes for my larger paintings. Use a brush in a size that corresponds to the size of the paper you are using.

The Robert Simmons Skyflow 3-inch (7.6cm) wash brush is another one I recommend. You can use this on a full-size sheet also, and it will give you a smooth wash.

IF YOU FEEL STUCK . . .

Call another artist, sign up for a class or put your painting away for a while and start another one. Sign up for a workshop. It's fun going away, meeting new artists and being with them. I think, too, a workshop offers you the opportunity to push yourself through some fears or areas you've been afraid of facing on your own. You'll have the support of your instructor and the other artists to help you get through. It will rejuvenate you and your work!

HOLBEIN HAKE BRUSHES
These are for applying either flat or graded washes to larger areas. They come in many sizes, are made out of goat hair and hold lots of water. Some less-expensive brushes out there look like them but will not give you an even wash; spend your money on good wash brushes.

BASIC MOP BRUSH
This is used for covering large areas wet-in-wet, such as filling in a background. It does not lay down washes as smoothly as larger, flatter brushes do.

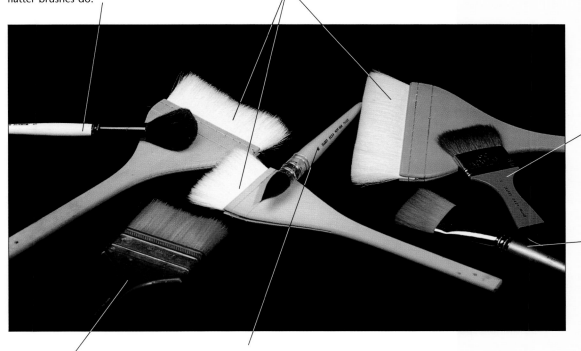

HOLBEIN KHX ELDORADO SERIES
This is a 1½-inch (3.8cm) flat brush that I use as a wash brush for smaller areas.

ISABEY 6421 SERIES
This is a pure squirrel 2-inch (5.1cm) wash brush.

ROBERT SIMMONS SKYFLOW
This brush is 3 inches (7.6cm) wide, holds a great deal of water and produces the smoothest washes.

ISABEY 6234 SERIES
This is a pure squirrel quill mop brush that holds a great deal of water, with a point that makes it not only wonderful for washes but also for detail work.

❦ *What is the difference between a flat wash and a graded wash?*
Flat washes are very even and require the use of a wide wash brush. Use them for backgrounds and other large areas that require a smooth-looking surface.

For a good overall flat wash, apply a thin layer of clear water to the entire back of the sheet with your wide wash brush. Flip the paper over so the right side is facing up. Wash with clear water on the front side also. The paper should not be sopping but should have an even sheen. Now apply a light color wash, and you will get a soft effect as it fuses into the wet paper. If you apply paint to dry paper, you might get streaks. If you want smooth washes, always remember to wet the side of the paper you want to paint your next wash on first.

A graded wash varies from dark to light, or has a variation in color. That usually means applying a layer of watercolor, usually across the top of the area of the paper you plan to wash, then grading it down by lightening it with water. It takes practice but can be very effective, particularly for skies in landscape paintings; you can achieve an atmospheric look that gives the painting more depth at the horizon line.

You can do washes in all sorts of ways for different effects. Look at some of the ways I have developed to do graded washes. In *To Be* I wanted to create the effect of the fog resting on top of the hills, yet slowly moving in—I was after movement. In *Morning Has Broken* I wanted to capture the sun peeking through the fog. In *And God Created the Sea* I wanted to create the light of the sun peeking through the fog onto some of the rocks and sea in a sort of rounded wash.

FLAT WASH

This is a flat wash in a simple landscape, meaning that the wash is one value over the entire page. Flat washes are often used for skies and backgrounds behind subject matter, but of course you can use them for whatever you want.

For a wash such as the one shown here in the sky, first wash with clear water then apply a thin, even layer of French Ultramarine Blue over your paper and let it dry. If it's not quite what you were going for, apply another wash. Let each glaze dry before you begin the next. Keep doing this, building up different colors until you get the color you want.

When you are finished building your glazes and your paper is completely dry, go in and work on your land, or whatever darker colors go over the glazes. If you want to save whites or lighter colors in your landscape, you would go around them or mask them out with masking fluid before you put in your washes or darker colors.

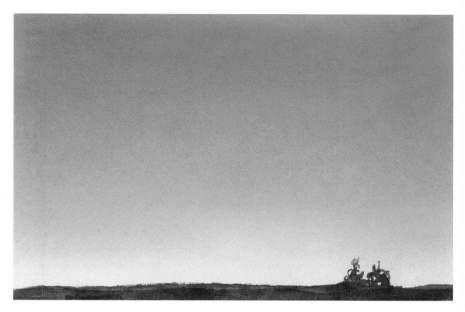

GRADED WASH

The graded sky here gives depth and a sense of light. For the effect shown, wet your paper with clear water on both sides. Load your wash brush with French Ultramarine Blue. Lay down a wash across the top with crisscross strokes one-third of the way down the paper. Quickly rinse the brush thoroughly. Shake most of the water out of it. With only the remaining clear water in your brush, pull the blue down the paper with your *clean* brush using crisscross strokes. It lightens as you blend down because you are only using water. Rinse the brush several times as you go, to ensure these value changes. Blend until smooth. The graded wash should be darker at the top, lighter at the bottom. The key here is working very quickly so the colors don't dry and set into the paper leaving streaks.

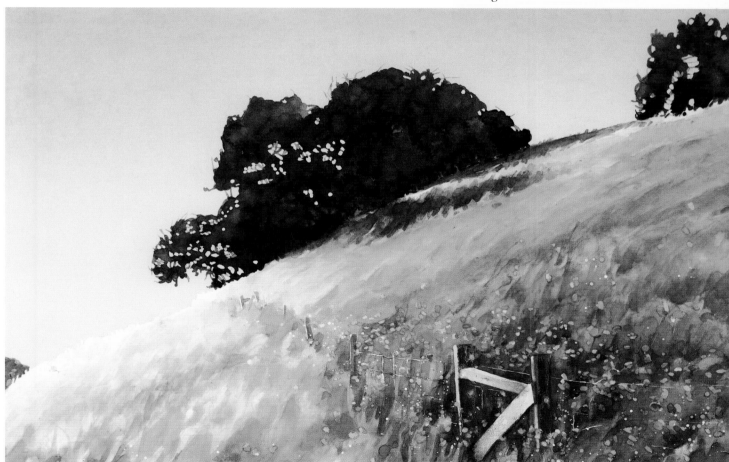

THIN, TRANSPARENT WASHES

In this painting, the sky has between ten and fifteen washes of various blues. The washes are so thin that all the colors you see in the land are in the sky as well, which ties the painting together quite nicely. These are all transparent watercolors, one on top of another. The graded wash gives the sky more of an atmospheric look to it, as well as more depth.

GOD'S GOLDEN ESSENCE
Watercolor on 300-lb. (640gsm)
Lana hot-pressed paper
21″ × 29″ (53.3cm × 73.7cm)
Private collection
Photo by Ron Zak

COUNT YOUR BLESSINGS
Be grateful for what you have every day!

How can I keep my paper down when I am doing an allover wash? After a while, the corners flip up and it's difficult to do the wash.

I highly recommend working on a piece of Plexiglas. I do not like my paper confined to anything with tape or staples. Wet paper sticks to the Plexiglas, making it extremely easy to do washes. The Plexiglas should be slightly bigger than your paper. Two to three inches (5 to 8cm) larger is ideal. Have one made in the size you want if you do not have one on hand.

Wet the back of the paper evenly with a wide wash brush and clear water. Then flip the paper over so that the right side of the paper faces upward. The paper sticks to the Plexiglas.

Before you begin your color wash, it is also important to lay down a clear water wash over the front of the paper. If bubbles occur under the paper in the beginning, carefully lift up your paper by one corner, wet the back of the paper where the bubbles are with more water and lay it down again. Bubbles mean that some areas on the back of the paper are not wet. You can also wash them out with your brush, pushing toward the edges of your paper—not too hard, or you will leave scrubbing marks. Remember, even the heavier papers are fragile.

When you have laid down a smooth color wash, pick your painting up carefully by the corners and move it to another piece of Plexiglas or another flat area. You do not want it sitting in a lot of water. Then wipe underneath the edges of the painting, all the way around, or the water that is still in the paper will seep back into the painting around the edges, leaving a border of blossoms I call "oozels." Keep an eye on your painting while it dries so this does not happen. Put fans on it to help it dry, and move it around on other flat areas. I have drying racks that I put paintings in when they are almost dry. Then they dry from underneath too. Mold can form when your paper sits in water.

CAREFULLY AVOID OOZLES
Unsightly oozles or blossoms occur when excess paint is drawn back into your paper while setting on the Plexiglass if it's too wet. Avoid these marks by carefully wiping up excess paint around your paper when you set it on the Plexiglas, as well as paint and water under the edges of the paper after each wash. Keep an eye on it while it is drying. Remember, it is wet on the bottom also. Move it to another dry place every once in a while to help keep it dry.

When glazing, do I have to wait for each wash to dry before applying the next?

Yes. This is the big key to glazing, and patience is important. You must let each layer dry before applying the next one. On a full-size sheet, it may take up to twenty minutes depending on the temperature of the room and the climate where you live. Remember, if you are working on Plexiglas, as described on page 62, both sides of the paper are wet, not just the top. It takes a while for 300-lb. (640 gsm) paper to dry. Work on another painting while your wash is drying; I work on four at a time, until it is time for the details on one painting. Then that particular painting gets my undivided attention.

Is there some way to remove a color once I have put it down on the paper?

You can scrub with oil painting brushes made of hog bristles. They are coarser than watercolor brushes (like an ink eraser compared to a regular eraser), so they scrub off color much easier. I use them only for emergencies and call them "magic brushes." When you do scrub with an oil brush, make sure your paper is dry first so you do not scrub right through the paper. And scrub gently. Watercolor brushes are too soft, so you need something with tougher hairs. Just be careful while you are scrubbing. Scrub marks show. Be gentle and work them into the shapes of the painting. If the object is round, scrub in that direction, not back and forth. Scrub with the shape. An electric eraser works pretty well too, but I would only use that for highlighting something. You have to be careful with an electric eraser so you do not run it right through the paper. It's pulled me out of a few predicaments.

When I glaze one layer of watercolor over another, won't I pick up some of the paint that's already on the paper? If so, how can I avoid this problem?

Yes. Some of the previous layer will usually lift off when you glaze one layer over another.

One way to deal with this problem is to use Aquacryl paints by Lascaux. Aquacryl (a mix of watercolor and acrylic in a jar) is a little thicker, goes on smoothly and acts similar to watercolor depending on the amount of water you add to it. It is also 100 percent lightfast. Incredible. It is great for applying washes on top of each other because the first wash does not lift up as easily as it can with many watercolors. You can stack color upon color and still maintain the richness of each color—underneath and on top! The colors are rich, yet they are all transparent. When you put a wash on and let it dry, it is pretty much permanent; that is, the Aquacryl color underneath still shines through when you glaze over it with a layer of a different color.

MAKE PAINTING A PRIORITY

Keeping away from the phone in order to enjoy uninterrupted painting might be difficult for you. I have gotten to the point where I shut off the ringer on the phone and turn off the volume on both it and the answering machine. The sounds jolt my nerves and serenity. I hear nothing. If I don't have to, I don't even screen calls. If I know someone is going to call, I pin the caller down as to approximately what time she will call. I let people know I am turning the phone off at a certain time, so they won't be able to reach me. It has taken me years not to be so curious about who's calling. Be patient with yourself. I return calls after my painting time. You'll have to confront those phone monsters trying to tempt you from your painting; they can be enormous. When I was a beginner, it was impossible for me to stay away from the telephone. I would pick it up every time it rang, afraid the person calling wouldn't like me if I didn't answer. If he wanted me to do something, I could never say no for the same fear. I would talk so much on the phone, I never got anything done. Setting your priorities is important.

If I am building glazes, how do I know which color to put over which to achieve a glowing effect?

For now, start out by laying your warmer color down first and then the cooler one on top. Keep that method in mind. Then begin to experiment by putting washes down in different orders. Let's say you wanted to create a beautiful, muted green with glazes. Using Aquacryl or watercolors, see how glazing with only two colors can create a green unlike any you have ever seen. Experiment with laying a wash of yellow down first, then lay a blue wash over the yellow. Next, using the same two colors, put a blue wash down first, with a yellow wash over the blue. When you put yellow over blue, you get a slightly more yellow-green. Blue over yellow gives you a little more bluish-green. Glazing is fun, and you can get wonderful effects using this method. You must try it!

If you keep your layers thin, your washes will subtly blend into the rest of the glazes gradually, so one wash that's not quite what you were after

Create Green with Glazes

WHAT YOU NEED

- Watercolor paper
- Water
- Wash brushes
- Wash plates (plastic party plates)
- Lascaux Aquacryl Paints:
 Lascaux Yellow
 Azure Blue

❶ GRADED YELLOW WASH

First wet your paper on the back and front. Then mix a yellow wash in one of your mixing plates with Aquacryl Lascaux Yellow. Lay down a graded yellow wash with a wash brush of your choice, beginning at the top. Quickly work down the rest of the paper with water, blending with crisscross strokes until even. This has watercolor and acrylic paint in it which sets in the paper faster, i.e. dries faster, so you have to work quicker using this medium, especially if you use little water. Here, I added lots of water. Let this first wash dry thoroughly.

❷ SECOND GLAZE

Wet the front and back of your paper as in step one (the color will not lift with Aquacryl paints). Mix Azure Blue Aquacryl in your wash plate with lots of water and apply with crisscross strokes. Then continue to blend down with clear water.

will not be very noticeable anyway. Just put down another one to correct it. My paintings have many layers of color. The layers are so thin, however, that you do not know there are so many colors. Building up glazes slowly will give you a beautiful glow, and if you keep them thin enough, you will have no streaks. You didn't know you were going to learn patience and painting at the same time, did you?

I usually begin with a general color plan in mind. Then I work intuitively, going for a feeling I want, rather than getting so technical, thinking about if this color or that color will work. If it looks good, I will use it. The painting will sometimes take me in another color direction and I will follow that one instead. Again, I trust my intuition, which I have developed through years of practice.

Once you learn your colors, you will just reach for each one automatically and will "just know" which one to use, without a doubt in your mind. Trust the learning process.

LET IT SIT

When you reach a point in your painting when you haven't a clue what to do next, stop! Let it go for a while. It's too frustrating to go on when your heart is no longer in it. Start a pile of unfinished paintings. Whatever you do, don't throw them away. This pile will be helpful to you later. Let it go for a while. Someday, you'll get the pile out, look at those paintings and suddenly you'll have all kinds of ideas as to what to do with them. During the time that has elapsed, you will have grown some (or a lot) in your painting and may be able to finish the paintings in a different light.

3 A UNIQUE GREEN
A green achieved by layering washes is not like a pure tube green or one mixed before laying down the wash. You can also keep building one color after another for a richer green—it's your painting! Try layering the same color washes in reverse order. Put down Azure Blue first, and let it dry. Glaze the yellow over the blue for a *slightly* different color. Glazing is fun; you can get wonderful effects with this method!

To Be
Watercolor on 300-lb. (640gsm)
hot-pressed paper
18" × 29" (45.7cm × 73.7cm)
Private collection
Photo by Ron Zak

PAINT WHAT YOU LOVE

I sometimes hear, "Why do you paint fog?" Or, "You ought to put more color in your paintings." I ignore such remarks. I paint what I love, and so should you. Paint what you love, not what others think you should paint.

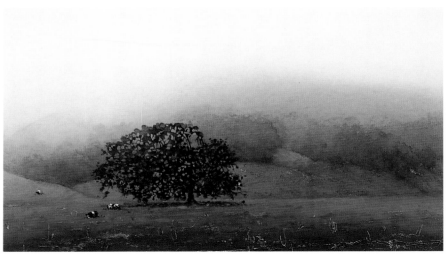

PULLING AND BLENDING COLOR

In this watercolor I wanted to create the effect of fog sitting on the top of the hills and moving slightly. This required pulling color up from the bottom of the painting into the foggy sky, using a great deal of blending.

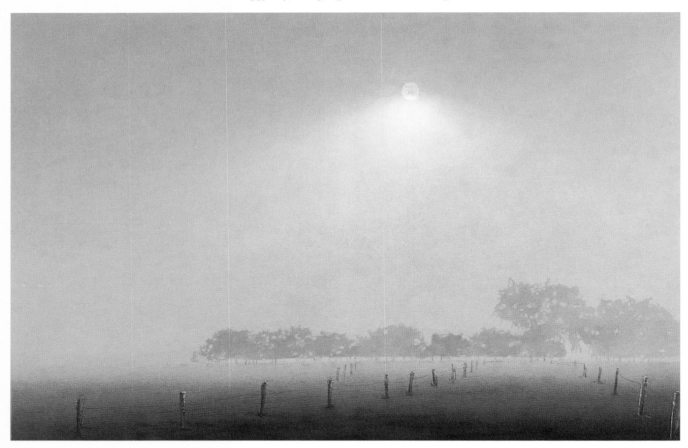

Morning Has Broken
Watercolor on 300-lb. (640gsm)
Lana hot-pressed paper
21" × 29" (53.3cm × 73.7cm)
Private collection
Photo by Ron Zak

CAPTURING A SCENE WITH WASHES

I often awoke to the sun trying to break through the fog when I lived on a ranch in Petaluma, California. I would just lie there wondering how to capture that beautiful sight on paper! I masked the sun and fence posts. Then I began my wash mixture at the top (though it looks as if it begins at the sun), worked down the right side at an angle and did the same on the other side. The middle was first blended into the side washes with clear water, then into the top. I blended the sides and top, paying attention to the many possible angles of light.

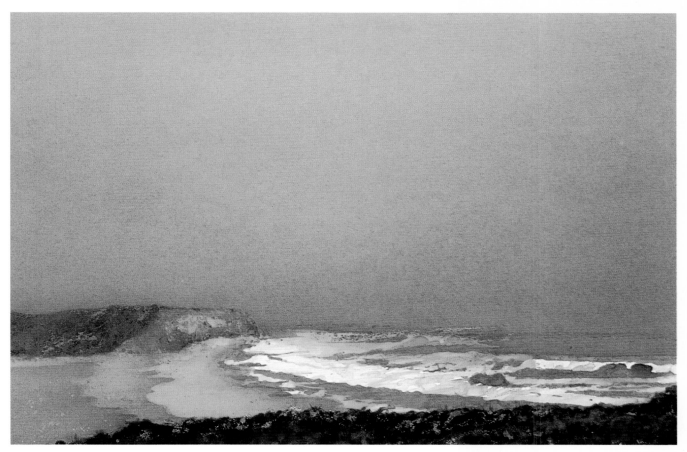

AND GOD CREATED THE SEA
Watercolor on 300-lb. (640gsm)
Lana hot-pressed paper
21" × 29" (53.3cm × 73.7cm)
Private collection
Photo by Ron Zak

How can I avoid streaks in my washes?

Have everything you need at hand before you start, and make sure the surface you will be working on is clean. You must work quickly, so you do not have to stop and look around for a thing. Mix your plate of color thoroughly so it's ready to go. Set out two or three tubs of clean water and all the brushes you are going to need, tissues, paper towels, everything.

Make sure you have a wide enough wash brush, and a good one. Wash the entire sheet of paper with clear water before you put your colored wash on. Not too much water, though; your paper should have a nice, even sheen to it. Now, with your wash brush, go into your plate of color and begin your wash at the top, adding more water as you go down the paper with your brushstrokes. Apply your brushstrokes with crisscross strokes.

Do not lay down washes too dark; build up washes slowly. Also make sure to mix your paints thoroughly. I mix my washes with an old round brush first, not my wash brush, because it is much too big. Because it's big, it could have a hidden paint speck inside. When you go to put on your wash, you could get a streak of pure pigment across your paper from the hidden paint.

I was halfway finished with a painting and the paper began to resist the paint in a small round area. Is this normal?

You have to be extremely careful when handling your paper because of the oils in your hands. Always handle around the edges. Once the oil gets on the paper, it could leave fingerprints on the paper and the paint will resist this oil. Never let anyone else touch your paintings either.

U-SHAPED "CURVED WASH" IN SKY

Here I tried to create the glow of light hitting rocks and sea, again as if the sun were trying to break through fog. I call this a "curved wash." First I masked the lighter areas of the sand and surf. Then I took a wash mix for the sky and went into my wet paper from the side, angling down. Then I went up again to the other side. Imagine doing your washes in a **U** shape.

CHECK FOR SCRATCHES

Before you begin laying down washes, make sure that your paper has no scratches in the surface or any obviously damaged areas. This is important when glazing because the paint will eventually settle into the groove of a scratch or blemish. Unless you have planned it that way, you usually do not want that unwanted line or splotch of color.

❧ *How can I avoid stray brush hairs in my washes? After completing a smooth wash, how can I get stray hairs from my brush off the paper without ruining my wash?*

Before using your brush, pull out some of the loose hairs. Even expensive brushes will lose a hair or two.

If you do get a hair or two, and your wash is a light one, just leave any stray hairs alone. It may drive you crazy to see a hair in your wash, but wait until it is completely dry. Then brush it off with a tissue—not your fingers, as some of the oil from your fingers may leave marks on the paper. The hairs will come right off if you gently sweep a tissue over them, barely touching the paper.

If you have a dark wash, the paint will pull away from the hairs, leaving marks. If you do not want these marks, you must remove the hairs before the wash dries. Going back into a wash is tricky. You could easily ruin it. You can go in and pick up the hairs with a tiny dry brush with a good tip. You need to practice that one. It's not easy. If you keep fussing and trying to pick that hair off the paper, the wash may become uneven, and you will simply have to begin your entire wash all over again. Your next wash will probably cover the little marks anyway.

❧ *What is a beaded wash?*

A beaded wash is painted with a round brush loaded with paint and water, instead of with a flat brush. With your paper tilted at an angle, you run a bead of paint across your paper, pulling the bead down, row by row, until you get an even wash. I prefer the wider brushes for glazing and washing. It takes a lot of practice to get beaded washes even and seems a little old-fashioned with all the great wash brushes on the market today.

bead

BEADED WASH

Tilt your support and paper 45 degrees, using something to prop up your board if need be. I am holding my paper here, but I usually use a board. Load your round brush with enough paint and water to take it all the way across the page. Begin at the top, laying down a wash evenly and carefully all the way across the paper. Working quickly, take more of the mixture and place it in the "bead" that forms, pulling it down into the next "row" (so to speak). Repeat across the paper, washing as evenly as possible. It takes practice to get an even beaded wash over a large area; larger, flat wash brushes are easier. The beaded wash is perfectly fine for smaller areas.

Glazing

❶ SKETCHING ON THE PAPER
First I made sure that the paper had no scratches in the surface or any obviously damaged areas. Then I very lightly sketched in my drawing. If your pencil marks are too dark, you will not be able to create a soft effect.

❷ MANY GLAZES LATER . . .
My first wash is barely visible. Here I laid down forty-three washes of Yellow Ochre, Raw Umber, Burnt Umber, Burnt Sienna and French Ultramarine Blue. Begin washes with a thin color at the bottom. One-third up the page, rinse your brush. Pull color from the bottom, blending with strokes of water. Rinse your brush often; blend in water only, not pigment, as you go up.

❸ MASKING IN TREE HOLES AND FENCE POSTS AFTER MANY MORE GLAZES
Continue washes of Burnt Sienna, Rose Dore, Aureolin, French Ultramarine Blue, Raw Sienna, Yellow Ochre, Violet, Burnt Umber and Raw Umber, in no particular order. After the washes dry block out tree holes and fence posts with masking fluid.

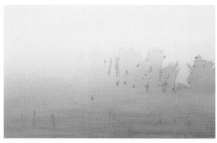

❹ LAYERING IN DETAIL
Start with a soft wash of Raw Sienna on the foreground trees, adding more water as you work back into the distance. I continued to layer Burnt Sienna, French Ultramarine Blue, Sap Green, Sepia, Burnt Umber and Raw Umber.

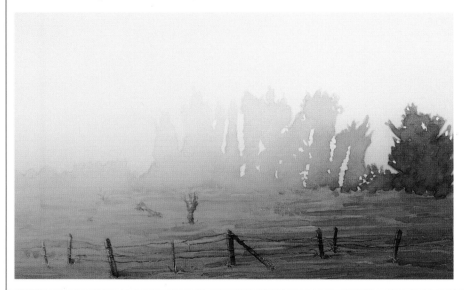

❺ FINAL WASHES AND DETAILS
I continued working on the trees with the colors mentioned in step four, then painted the foreground and some trees with a more direct approach using brushstrokes instead of washes. After around one hundred washes, I pulled off the masking fluid and began adding the details of landscape and fence that completed this painting.

GLEN OAKES
Watercolor on 300-lb. (640gsm)
Lana hot-pressed paper
21″ × 29″ (53.3cm × 73.7cm)
Private collection
Photo by Ron Zak

DODGE DISAPPROVING PEOPLE

Avoid people who do not really support you and your art, who make judgments about you like, "Oh, you'll never paint!" or, "Why are you painting clouds?" Be careful who you let into your studio or painting area.

&❧ *What is mud, and how do I get into it?*
The term "mud," in reference to watercolor, means a lack of vibrant color. Most beginners get into the mud when they are first learning how to paint and mix colors. Yet, if you have some understanding about it, you will know that just because you create a muddy mess does not mean you cannot paint. It's normal for the beginner. Even advanced students get into the mud! It's part of watercolor. "Mud" could be my next book; I've been in it so many times.

You can get into the mud in many ways. For example, you could buy inferior student-grade paints. You might not clean your brushes properly after you finish using a color. You might mix the wrong colors for the results you want. You might mix two colors, then add a third you just knew was going to work and did not. You might accidentally pick up some color with your brush that you did not intend to mix. You might use too much water with your paint, put another color over the one you just put down while it's still wet, and the colors bleed into each other to make mud. To make matters worse, when you see your painting getting into the mud, the next thing your brain tells you to do is to fix it *now*. You do not want to wait for it to dry, so you go in with more wet color or more water. You fuss until the paper no longer takes paint or water and you have an even bigger pool of mud on your paper.

My mud occurs when I become excited and do not let my paint dry before painting over it; I'm afraid I'll lose all the ideas zooming into my brain! I'm afraid I'll forget them if I have to stop and wait for something to dry!

&❧ *How can I avoid getting into the mud?*
By buying professional artists'-quality paints, by cleaning your brushes properly, by learning which colors to mix for desired results and by letting layers of paint dry before painting over them. One thing I have learned to do is to work all over the painting in order to avoid mud. Once you lay down one color, move to another area; when the first color is dry, go back to that area. This way there is no mud, plus you get to see the whole painting develop instead of one little section of it. You can also choose to put a partially finished painting away to dry while you work on another one. Drying is the key word here. Let the paint dry before adding another on top.

&❧ *How can I get out of the mud once I am in it, or at least make creative use of it?*
If your mud is still wet, you can try soaking it up with a paper towel or tissue. You might also be able to lift it up with a brush.

Do you want to try to work with the mud? Waiting for it to dry naturally may produce some interesting results. You can blow it with a hair dryer, which may make the mud run off the paper if there is a lot of water in it. You can pick up your painting, let the mud drip off and see what kind of design you get.

Sometimes all you can do is set your painting aside and begin another one. Who wants the frustration? When you become manic about it and your heart is not in it, just stop. Try to look at your failures as gifts; you have gained from the experience. You have not wasted your time, energy, a sheet of paper or your money—and you are not a lousy painter! You have only gained from the experience. You are growing and learning. That's a gift. In the next painting you do, you will try something a little different. This is where real creativity kicks in.

SOMEPLACE FAR AWAY
Watercolor on 300-lb. (640gsm)
Lana hot-pressed paper
21"×29" (53.3cm×73.7cm)
Collection of the artist
Photo by Ron Zak

I want to loosen up some. My paintings are so tight. I want to splash around and have fun, but I cannot seem to make that leap. Do you have any suggestions?

There are so many things to learn about watercolor. It takes a while. You control the water and paint as best you can while you learn. You stay in the lines and use a tiny brush. That seems pretty safe, and is actually a good way to learn control of this medium, but it will not give you that watercolor look you love so much. Don't worry. You are learning step by step.

Once you have learned the medium, you may get brave. You may want to break away from this control and take a risk. The break usually occurs when you feel more confident. I began painting with tiny brushes because I had better control with smaller brushes; no. 7 was my largest. One day, feeling brave, I tried a bigger brush and loved it. I felt out of control with the bigger brush and at the same time in control because I knew my medium well by then. My brushstrokes were bigger and not as tight. When you are ready, make the leap to a larger brush—no. 10 or no. 12. See what happens. Try to see if you can borrow one from someone to see if you like it before you invest the money. This helped me a great deal.

LOOSEN UP!

Have fun! Laugh! Listen to your favorite music! Sing! It's a great life!

Remember—there are no rules...

VALUES CREATE DIMENSION

When the next crescent moon rises, go look at it. Do you see just its crescent shape, or do you see the dimensional roundness of its form? At first glance you'll probably just see its white. Stare at it for a while, until you begin to see the roundness of it—the whole moon. Part of it is in shadow, but it's still there. After you see the white, see how the shades go from white to getting darker and darker as they wrap around the moon, giving it dimension.

A BLESSING
Watercolor on 300-lb. (640gsm) Lana hot-pressed paper
21″×9″ (53.3cm×73.7cm)
Private collection
Photo by Ron Zak

Tonal Values

Values are lights and darks; but let's replace the word "value" with the word "shade" until you have a better understanding of how the word "value" relates to painting. If I say a shade is too light or too dark, it immediately rings a bell with most people. "Let's go sit under the shade of the tree." Everyone knows that the shade is the dark part of the grass under the tree—the shady area, or the darkest value of the grass.

In order to give an object form (the appearance of dimensional shape and structure), you need lights, darks and shades (values) in between. For instance, the sun shining directly on the side of the barn on page 80 is the lightest value on that object; in fact, it's the white of the paper. This light value makes it look and feel warmer than the rest of the barn. The values on the shady side of the barn are darker and cooler colors. Even when an object is shaded, it still has form. There is still something happening within that dark value (shade) of the object. The barn wall and bushes are still there. It's not just a big blob of dark color. You should still be able to see the texture of the barn wall and bushes, only in a darker shade (value) of color.

It's important to get darker values dark enough to create dimension; otherwise everything looks flat. Since you usually can't easily lift off anything dark that you put down in watercolor, go slow, building up darker colors in layers until you build up your self-confidence. Eventually you'll get to a point where you just put that dark color down with no fear.

Start with the basic exercises and charts in this chapter. You'll soon catch on. I've also included some finished paintings with wonderful values so you can see different ways to apply lights and darks in your own paintings. In *A Blessing* the white of the horse is the white of the paper, and I used darker values around him to make him stand out.

WORK FROM LIFE, LOOK AT OTHER WATERCOLORS

If you are just beginning, I suggest working from a still life or looking at other watercolors as opposed to reference photographs. Photos are difficult for the beginner to translate into a watercolor. Find a subject or a watercolor that moves you. Keep it simple—a piece of fruit, a flower done in watercolor from a greeting card—something easy. Practice by looking at other watercolors, flowers, landscapes and still lifes. You can see the brushstrokes and colors in other watercolors, but you don't have Kodak colors on your palette.

How do values give an object dimension?

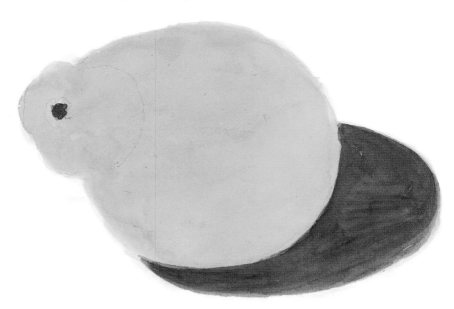

A FLAT LOOK
This tangelo has only two values, dark and light. Since there are no other shades between these two to make the fruit look rounded, it looks flat. It doesn't have the appearance of dimensional form. It looks flat because there are no other shades (values) in between the light and dark to give it that third dimension.

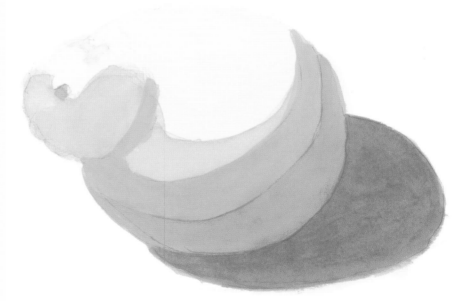

APPEARANCE OF FORM
Here I've broken down the tangelo into five values separated by lines, with the lightest value where the light source is shining down directly on the fruit and the darkest underneath it, where the shadow is. Each shade gets darker and darker as it goes away from the light, giving the object form. Even with the lines, the object looks more round because the values are correct. By squinting your eyes, the fruit looks round. This is a great exercise to do with any object to learn about values.

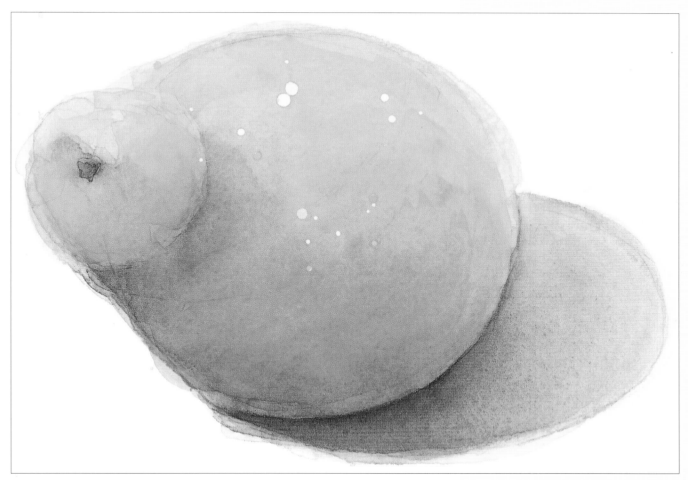

BLENDING INCREASES DIMENSION

Here you see the completed piece of fruit, with all of the different values blended to give it dimension. The tangelo was blended and layered with a good range of values. Again, the lightest value is at the top, where the light is shining directly down on it, and the darkest value is at the bottom shadow underneath, where the tangelo is blocking the light source.

The color of the fruit reflects onto the surface on which it sits. Mix the fruit's local color (in this case orange), then paint it and the shadow it casts all at once. Since the fruit's local color reflects off the surface it sits on, put that in the shadow. Let it dry. Since orange's complement is blue, mix a blue color with a little of the orange to get a gray. Blend the gray into the bottom of the fruit and its cast shadow. Let it dry. The shadow is interesting because the white of the paper and the orange paint peek through the blue-gray paint. Make the mixture a little darker by adding more blue and orange. Paint the shadow darker under the fruit, and blend it as you move away from under the fruit up into it, using more and more water as you paint up the fruit. The different values of orange give an appearance of roundness, with darks mixed with complements at the bottom.

You don't have the shadow dark enough if your object looks like it's floating in space and not sitting on a surface. Going dark slowly, layer by layer, is good advice for the beginner. Just make sure you let each layer dry before you add another one.

MAKING SHADOWS INTERESTING

Shadows are shapes and color, not just black. What you should put down to paint realistically is not always what you *think* you should put down. You must struggle against your preconceptions. A shadowed object is the same object as when light shines directly on it. When a tree shadow falls on grass, it's still grass, in sun or shadow; it just appears darker. Something interesting should go on in a shadow's darkness. Pay attention not only to its shape, but also to colors within that shape.

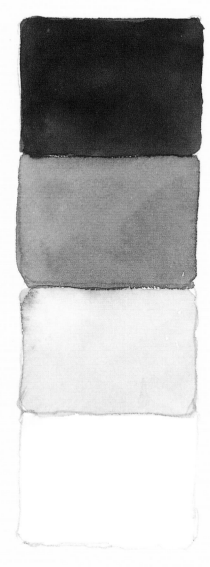

SIMPLE FOUR-VALUE SCALE

First draw four squares, as seen here. Pick a color. Begin by filling the top square with your darkest value. Gradually add more water for the second and third squares. Let each dry before you do the next, or the paint from one square will run into the others. The lightest square, at the bottom, is the white of the paper.

PAINT AND WATER

Play with your water and paint to learn how they work together. Splash around, watching the water and paint ooze all over your paper, so out of control while in control. Watercolor has such a spirit of its own!

≈ *What is a value scale, and how can I use it to help me learn to make a simple object look dimensional?*

In order to make values work in your painting, you must have contrast, or differences between values. The easiest way to see this contrast is on a value scale showing high values (lights) and low values (darks).

Make a value scale with just four values, as I've done at left, then choose one simple object like the box used on the next page. You are going to refer to your value scale when setting up and painting your object. Set up your object with a strong light shining on it, until you approximate the four values on your value scale. The top of the box, where the light is hitting it most directly, is the lightest value on the scale (the white of the paper). The darkest part of the shadow area corresponds to the darkest value on the scale, while the sides of the box are the other two values (or shades) in between. By using one color with varying amounts of water, you can make the box look three-dimensional by using only the four values corresponding to the scale.

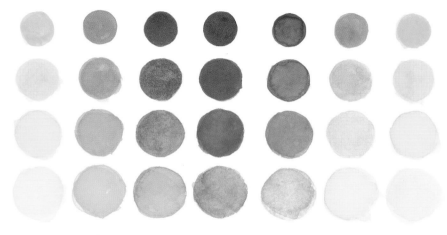

COLOR VALUE CHART

Draw circles as I've done here, seven across and four down. Paint in the top row of circles with your colors in the same order as the color wheel on page 47, only going across. You want this top row to be as dark as possible, so use these colors right out of the tube, with just enough water to make them spread in the circle. For the second row, add a little more water (but not too much) to the mixture you just made. Paint in the circles going across, making sure they are lighter in value than the top row. Repeat the same for the third and fourth rows. Follow what I've done for this chart, with each row getting lighter in value as you paint down from the top circle.

Values

❶ SIMPLE STILL-LIFE ARRANGEMENT

Place a simple white box against a simple backdrop, with a lamp (one with a swing arm is best) to one side so that you create strong light and dark values. Play with the lighting to get at least four values, with the darkest value being the shadow cast by the box and the lightest value being the white at the top of the box. Try to get the same values in your setup that you made in your four-value chart.

❷ TWO SIDES AND CAST SHADOW

Use the same color you used for your four-value chart. Mix it again until you get your second-lightest value on the chart (the top of the box is your lightest value, so it will be left as the white of the paper). When you think you have the second-lightest value mixed, apply it to a piece of scrap paper and test it against your chart to see if it matches that value. On your water-color paper, paint two sides of the box and the shadow *all at once* with this mixture, remembering to leave the top of the box white. Let it dry.

WHAT YOU NEED

- Simple white box
- Table or surface to set your box on that is large enough to serve as a backdrop for your box
- Plain backdrop material, such as black velvet
- Lamp (one with a swing arm is best)
- Palette
- Paint in a color of your choice
- Water
- Brush of your choice
- Watercolor paper
- Four-step value chart for comparison

❸ ONE SIDE AND CAST SHADOW

With the same mixture, paint the two sides of the box that are in shadow, as well as the shadow cast by the box, *all at once.* Let it dry. See how the values are coming to life! The shadow side of the box should match the next-to-darkest value on your chart. If it isn't dark enough, keep layering color until it does match, painting the shadow at the same time. Keep referring to your four-step value chart in order to get the correct values to form the box.

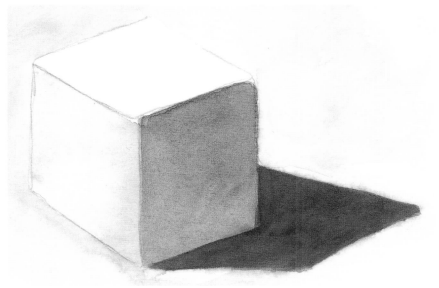

❹ DARKEST CAST SHADOW

Paint in the shadow cast by the box *only*, using the same mixture of paint, until you get the darkest value on your four-value chart. Simply layer more paint if it's not dark enough. Let dry. If you want to bring out the white on the top of the box a little more, paint a light wash of the same mixture around the box.

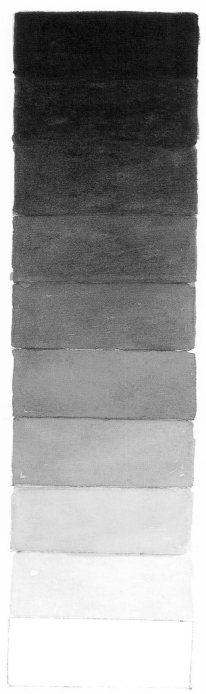

I've heard that I need at least eight to ten values in a painting to make it successful. How can I learn to get a good range of values? I often either go too dark or too light, and my paintings look splotchy.

If all of your values are either very light or very dark, with nothing in between, your paintings will look splotchy. This is because when you want a shadow or another dark object, you paint it in as a dark blob, and pretty soon the painting just looks like a bunch of light and dark blobs.

Make a value chart of ten values, as shown at left. Use a color that's strong enough to make a good dark. I've used Burnt Umber. You may have to do several charts before you get this one right. It's a lot harder than it looks. This chart will be a great reference tool to keep next to you when painting.

If you are a traditional painter attempting to paint in a realistic style, you need a good range of values. In Dean Mitchell's *James McKinney*, below, the shades of grays create a variety of subtle transitions of color. This painting has values from white to dark and all the values in between.

Another way to check your range of values is with a piece of green acetate, which you can buy at an art store or through a catalog. Make it any size you want, and glue a mat around it, to keep it from tearing and wrinkling. When you need to check your range of values, lay the acetate over your painting and you'll be able to see your splotchy areas immediately. If you are not painting dark enough, that will show up also.

JAMES MCKINNEY
Dean Mitchell
Watercolor on hot-pressed Crescent board
20″ × 30″ (50.8cm × 76.2cm)
Private collection
Photo by artist

TEN-VALUE CHART
Draw ten rectangles as I've done here. Begin by painting your darkest value in the top space, almost right out of the tube, adding only enough water to spread it in the box. Add a little more water to the mixture for each box, getting lighter and lighter as you work down the value scale. Again, the bottom value is the white of your paper. This chart is a bit trickier than the four-value chart; you may have to do several of these before you get ten distinct values.

How do I determine what value something is or should be? For example, if my value scale is in ranges of gray or brown, how do I determine what the values are in a color reference photograph?

A handy tool that I use and you can buy in any art store or catalog is a value finder card by Liquitex. This value scale has nine values and will enable you to find corresponding value for most colors.

For example, if, in the photo of the rose shown here, you want to see where lights and darks fall on the value scale, place the value finder on a particular area and look through the holes. The color's lightness or darkness will more closely match one hole on the chart than the others. Then you can determine how light or dark the area on your painting should be. This little card is so useful. You'd be amazed at what you see through the holes. You may think you have a value right, but when you place the hole on the area you want to check, you may realize you're still far away from the value you wanted. You can also make your own chart and punch holes in it! Making a black-and-white photocopy of your colored photo to see your values is also very helpful.

VALUE FINDER CARD

This Liquitex value finder card has nine values and no white. If you added white you'd have your ten values. The holes in each value enable you to find the corresponding value (shade) that most closely matches most colors. Place the holes in the value finder over the value you want to check in your painting. When you look through the holes, one of the grays on the chart should match more closely than the others with the value you are checking. Squinting your eyes will help.

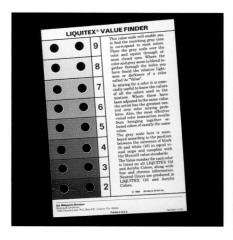

MATCHING A REFERENCE PHOTO
VALUE TO YOUR PAINTING

In this reference photograph of a pink rose, the petal whose value is to be checked against a painting is outlined above. Place the value finder on top of that petal only. Then look down through the holes until you see one that blends more closely with that petal than the others. In this case it's value 7. Then go back to your painting and place the value finder on the corresponding petal to see if it matches value 7. If the value doesn't match, work on it until it does. It's amazing how dark you might think your value is until you check it out with this handy tool. You may discover that you're not even halfway there!

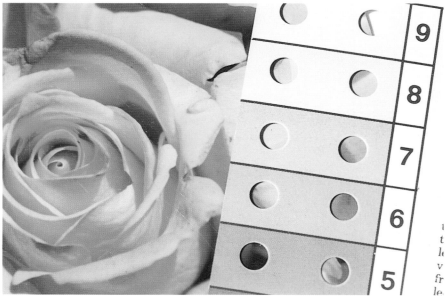

What is a value sketch, what is it used for and how can it help me?
It's a quick sketch done in black and white before you begin your painting to help you determine where your lights, darks and in between values are in the painting. This gives you the chance to work out all of your value problems in pencil.

WORKING OUT VALUES

Here's a quick value sketch of the barn on page 27. Value sketches, usually done in black and white, help you work out your values before you begin your actual painting. What values do you see? Is there a good range, or do they look splotchy? Are they too light or too dark? Does your focal point show up well, or is it lost?

How can I make my main subject really stand out in a painting? My subject often gets lost with everything else in the painting. Help!
The subject you want your viewer to focus on is called your focal point. One way to make it really pop out and say something to the viewer is by keeping your focal point a light value, with all of the other values around it darker. If your focal point is not standing out as much as you would like it to, then go darker around it. If you're afraid of going too dark too soon, go slowly, working in layers and getting darker gradually. You'll know when you're there. It can be scary to go dark in watercolor because it's not easy to change something and make it light again once you've laid down a dark.

See Judith Klausenstock's painting *Five White Squash* at right. There are many ranges of values in this watercolor, but the darker values around the squash push them out. You're not looking around to see what and where the main subject is. It grabs you and pulls you in.

If you want something dark to stand out, then put a lighter color next to it. If you want something light to stand out, then put a dark next to it. You have to think not just about the color you are putting down for a particular subject but also about the color that goes around it or next to it.

⬩ Can you recommend a good book on value?
There are two I recommend: Carole Katchen's *Dramatize Your Paintings With Tonal Value* (Cincinnati: North Light Books, 1993) and *Tonal Values* by Angela Gair (Cincinnati: North Light Books, 1992).

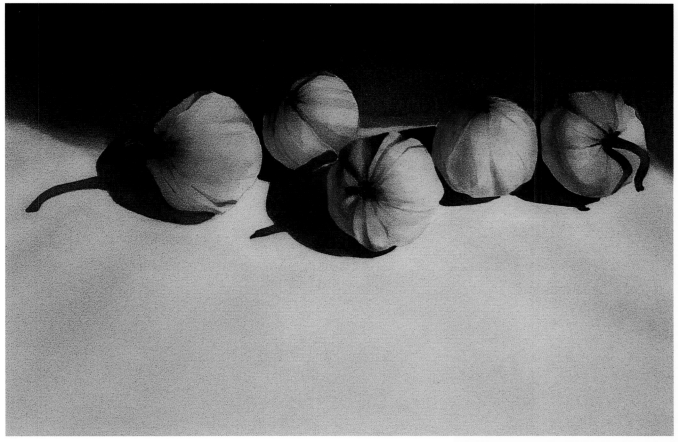

CONTRAST CREATES DRAMA

The focal point in this painting, which pulls you in immediately, is obviously the squash. The squash pop right out at you because of the push and pull of the contrast between the light squash and the dark value around them. There are also subtle values in between the light and dark. It's gutsy to put down darks in watercolor, but look at the dramatic effect you can create by doing so.

FIVE WHITE SQUASH
Judith Klausenstock
Watercolor on 140-lb. (300gsm)
Arches watercolor paper
18″ × 25″ (45.7cm × 63.5cm)
Collection of the artist
Photo by the artist

TRAIN YOUR EYE

Work from life, whether outdoors or indoors. Set up a still life in your studio, sign up for a life-drawing class or go outdoors. Many students want to know if drawing from life is important. It is, because working from life trains your eye to see values and colors as they actually appear. You don't learn that from a photograph. You are just copying at that point, not "seeing."

HOMEBODY WAYS OF WORKING FROM LIFE

I have always enjoyed working from life—outdoors, live models, anything. Yet I am such a homebody. I began setting up simple still lifes in my studio and spent no more than a couple of hours on each one. Try drawing your hand or foot sometimes. Whether you are at home or not, you can also carry a sketchbook around with you so you can practice your drawing wherever you are.

ONE FOGGY DAY
Watercolor on 140-lb. (300gsm) cold-pressed paper
11"×14" (27.9cm×35.6cm)
Collection of the artist
Photo by Jerry Mennenga

Painting Outdoors, on Location and From Life

Outdoor painting is very different from indoor painting. There are many elements you have to deal with, such as precipitation, wind, baking sun and bitter cold. The most important aspect of painting outdoors is how it helps train your eye to see.

To capture the essence of what you see, you must know your subject. When painting outdoors, it's as though you are "in your painting." You certainly cannot get any closer to your subject than by being there. Everything is so fresh and alive!

I paint my environment as I'm out in it every day. Study yours by being outdoors daily, if you can. Observe nature's colors, how they complement one another. Notice the change of seasons. Splash in mud puddles. Walk in the rain and fog. Smell the freshness of the air. Feel the mist on your face. To paint your environment well, you need to be in it and feel it. Only then can you capture the essence of it, in or out of the studio. My paintings would not have the same feeling if I just took a couple of photographs once in a while. I paint what I see every day, what I know so well. I take all this back to the studio with me, and when I am painting, I can feel the outdoors. I guess you would call me a "plein in" painter more than a plein air (open air) painter.

There is a certain value in painting from life. It is not easy to capture the freshness of a painting done from life when using a reference slide or photograph. That is not to say that you cannot make your masterpiece in your studio. You can paint wherever you feel like painting.

Outside you have such a short time to work. The light and weather conditions change so quickly, leaving you little time to fuss over your painting. This is good! Some of the greatest paintings are those painted outdoors. You capture the emotion of the moment very quickly, so there is great energy in the painting. You either hit it or miss.

THE ARTIST'S CALLING

" The only way the artist can appeal to humanity is in the guise of the high priest. He must show people more—more than they already see, and he must show them with so much human sympathy and understanding that they will recognize it as if they themselves had seen the beauty and the glory."

—Charles Webster Hawthorne
(American painter, founder of the
Cape Cod School of Art)

Fog at Two Harbors
by Frank LaLumia
Watercolor on 140-lb. (300gsm)
Arches cold-pressed paper
15″ × 22″ (38.1cm × 55.9cm)
Private collection
Painted at the Plein Air Painters of America Annual
Exhibition and Sale, November 1997

🔊 *Why paint outdoors, with changing light, high winds, biting mosquitoes, baking sun, chilling winters or other adverse conditions when I can shoot a reference photograph or slide and work comfortably in my studio?* Read what Frank LaLumia, a Signature Member of the Plein Air Painters of America, has to say about painting outdoors. I think you will find his thoughts inspiring and beneficial.

Your question . . . goes to the heart of what it means to be an artist. Painting from life is the great teacher. This is not my good idea. It is the wisdom of the ages handed down to us. Learning to paint means learning to see, and that takes years of study. Nature gives up her secrets grudgingly, and only to those most determined to crack open her mysteries. . . . The road is long and difficult enough without making the mistake of substituting photography for observation. A photograph is an approximation at best, useful in recording details but woefully inadequate in conveying the magical play of light. To put it another way, a photograph is a lie. Because the information you need most isn't present in a photograph, the artist falls back upon other things: lessons learned from a book or a charismatic teacher, or something that has worked in the past. At this point, one sinks into the dreary world of mannerism. From the standpoint of making fine art, you are "circling the drain."

As a plein air painter with twenty-five years [of] experience, I sympathize deeply with the blowing wind and biting mosquitoes part of your question! I would only add that an apple on the kitchen table is also plein air painting [from life]. You don't have to trek at high elevations to join the brotherhood or get the benefit.

Painting from life teaches you how to use photography in an effective way. Master that and you will probably find that using photographs isn't nearly as much fun as *plein air* painting.

What is a French easel?

A French easel is a portable sketch box, made out of wood, that unfolds into an easel that adjusts in height and sits at any angle. The legs are adjustable, so you can bring a stool along with you to paint outside. You can also use it on top of a table, by not expanding the legs and by tilting it up a little. It also has a metal-lined drawer with a palette for paints.

For backpacking, there is also a French easel about half the size of the original one. I have not tried this one yet, but I have asked my students, and they seem to like it.

Do you recommend a French easel for painting outdoors?

From my experience, yes I do. I have a Jullian easel (the original French box easel designed by Roger Jullian in 1945), which has held up for many years and would be good for any watercolor artist. If you decide you like painting outdoors, then you can begin to customize your easel to suit you more or maybe design your own outfit. For instance, see the tomato juice can hanging off the left side of my easel? Someone made that to hold my brushes or water. He riveted a handle onto the large can so it would hang over the side of the easel.

I used to sit on a blanket and prop up a board with paper on it, with my supplies all over the blanket. If you try this method, bring a solid-color blanket so you can find everything. You cannot see your supplies as well on something printed and could lose many little things. I prefer my easel now.

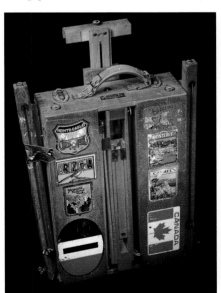

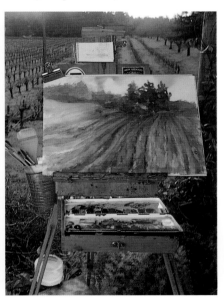

What kind of palette do you recommend for outdoor painting?

I have a metal folding palette made by Holbein. It folds flat and fits nicely into anything I carry my supplies in. It sits perfectly on the French easel.

FOLDING METAL PALETTE ▶
Made by Holbein, this palette folds flat and fits nicely into almost anything you might want to carry your supplies in. It has a black finish on the outside, white enamel on the inside, a thumbhole, color wells, large mixing areas, and it sits perfectly on your French easel.

CARRY BRUSHES SEPARATELY
Sometimes tiny items and brushes have slipped out of my French easel, so I carry them in my canvas bag.

Remember—there are no rules...

◀ JULLIAN FRENCH EASEL
This easel is a portable sketch box made out of wood; it unfolds into an easel that adjusts in height and sits at any angle. The legs are adjustable, so you can bring a stool along with you to paint outside. It also has a metal-lined drawer with a palette for your paints. I carry my tiny items and brushes separately as sometimes they have fallen out of the easel. I only carry paints and things that will not slip out of the cracks; everything else goes into my canvas bag.

SPEND TIME NETWORKING
Associate with other artists whom you like and respect.

TAKE THE RISK!

Remember—there are no rules...

PRE-STRETCHED WATERCOLOR BLOCKS
Pads of paper bound around the edges with glue, called watercolor blocks, are good for outdoor painting. The sheets form a block backed with cardboard, for an automatic support. The blocks come in various sizes and surfaces with the paper already stretched. Buy a couple for outdoor painting. When you finish a painting, you must let it dry before peeling it off the block very carefully with a palette knife (see page 15). If you have another block, you can finish one painting, set it aside, grab another block and begin another painting!

How should I carry my water?

Carry large plastic bottles, one for watercolor water and another for drinking. I also carry a collapsible plastic jug to hang off the easel. I sometimes use an old plastic yogurt container that fits into the brush and water holder someone made for me (see page 85). In this setup of my French easel, however, I usually use the can to store my brushes. Sometimes you are lucky enough to be around water, so you will not have to carry it.

What paper do you recommend for painting outdoors? Are there various considerations for different situations?

You have to take a couple of things into consideration. One is the climate. Paper, water and paint react differently depending on the weather. Heavier paper is better if it is a hot, dry climate. I was teaching a workshop one summer in Taos, New Mexico. It was very hot, and as soon as the paint touched the paper, it dried. For cool, damp weather, 140-lb. (300gsm) paper is good. *One Foggy Day* (page 82) was quite a struggle because the painting would not dry. It was a foggy, cold and damp day. I have learned since then that watercolor blocks take longer to dry as opposed to a sheet of paper, particularly in foggy, damp weather.

Watercolor blocks are usually what I use outside, mostly for convenience. These are blocks of paper already stretched and glued together to form a block of many sheets of paper. Because they are thick, they have the support you need behind your paper. They are usually made of 140-lb. (300gsm) paper and come in various surfaces and sizes. Take several with you if you can because when you finish, your painting may still be wet and you need to allow it to dry before you peel it off the block. While one painting is drying, you can work on another. When your painting is dry, carefully peel off the top sheet using a palette knife around the edges. You can also bring sheets of watercolor paper, a board to support your paper and some clamps to secure your paper.

The surface of your paper is something to think about also. The rougher the paper, the more you can tilt it on your easel. It will drip some, but not like it will on a hot-pressed paper; the paint will grab more in the tooth of the rough paper.

🖎 *What other gear do I need to take with me when I paint outdoors?*
This is the list of what you need:

- pencil
- pencil sharpener
- kneaded eraser
- brushes
- spray bottle
- small sketch pad for thumbnail sketches
- a couple of clamps
- watercolor paper with a board to support it or some watercolor blocks
- paints
- palette
- paper towels or tissues
- water jug to carry water to paint with
- a container to put water in
- water to drink
- trash bag
- slide mount
- camera (in case you do not finish on location, you can take photos so you'll have reference photos to finish your painting back in your studio)
- easel

Depending on the season, you may need a sun hat (with just a visor, you can burn the top of your head), sunscreen, bug spray, layered clothes, gloves with no fingertips, snacks, whatever. Some artists bring stools and umbrellas. It's difficult to see what you are painting with glare from the sun on your paper, so an umbrella is a great asset.

🖎 *I travel a great deal. What sketching and painting supplies do you recommend taking that would fit in my suitcase?*
There are several compact watercolor kits on the market. I would invest in either the cakes or tubes of watercolors. They each come with a tiny brush, but I would take a couple of my favorite brushes and a small watercolor sketchbook along. It's fun to keep a painting journal when you travel.

FORMULAS AND TECHNIQUES

Art is about creating a feeling. Techniques are only tools for you to express yourself. Everyone wants a formula. Don't become stuck in this way of thinking and begin formula painting, or all your paintings will look the same. Use a bunch of techniques. I don't want people to say, "Gee, I wish she'd stop using that sponge on every painting!" I want them to say, "How did she do that?" Formulas and techniques are only tools. If you do use one, try to be creative about it.

◄ **STURDY CANVAS BAG**
I carry most of my gear in this sturdy canvas bag.

SUPPLIES FOR TRAVELING
These supplies tuck nicely into a suitcase (if you are going on a serious painting trip, you might want to take more): small watercolor sketchbook, brushes, watercolor set, eraser, pencil and sharpener. You will be able to find water and containers almost anywhere. It's also fun to keep a painting journal of where you have traveled.

FORMULA FOR DEPTH

Value and color temperature will give your landscape depth. Though there are no rules in watercolor, try using cooler, lighter colors with less detail in the distance, and warmer, darker colors with more detail in the foreground.

🔊 *How do I get depth in my landscapes so things look as if they are off in the distance?*

At one time my painting *Rainy Days*, below, was monochromatic and almost a value chart in itself. I decided to make a ten-value chart with the same greens I used in the painting. Place a value chart under your painting. You can see the value changes and how you create depth with your lighter values of colors in the distance and darker and more detailed ones in the foreground.

Everything in the background should be kind of fuzzy, with less and less detail as you go back into the painting. When you are outside painting and you see a tree off in the distance, do you see the detail of the tree? No, you see the shape and color of the tree only. Our minds tell us there are many leaves on the tree, but we do not see those leaves. Many beginners, not knowing the difference, listen to their minds and not their eyes. They paint every leaf and every blade of grass into a painting. This is what it means to learn to see. Training our minds to get out of the way and paint what we see and not what we think we see. Your colors should also be lighter and cooler the farther back you go.

I realize that you probably do not want all of your landscapes to be monochromatic in color. Remember this simple formula: cooler, lighter colors in the distance, with less detail; warmer colors in the foreground, with darker values and more detail.

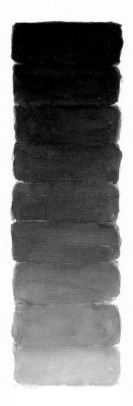

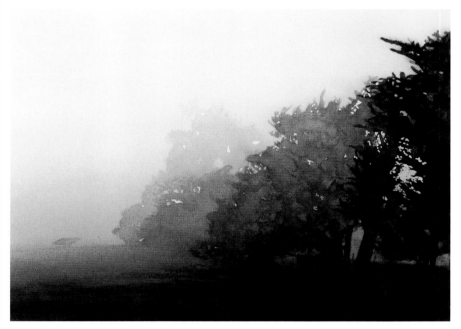

RAINY DAYS
Watercolor on 300-lb. (640gsm)
Lana hot-pressed paper
21" × 29" (53.3cm × 73.7cm)
Private collection
Photo by Ron Zak

VALUE PAINTING, VALUE CHART

Rainy Days is almost a value chart in itself, so it is good for showing you how to get depth in your paintings using values. Use lighter value in your background to push everything off into the distance; use darker values in the foreground.

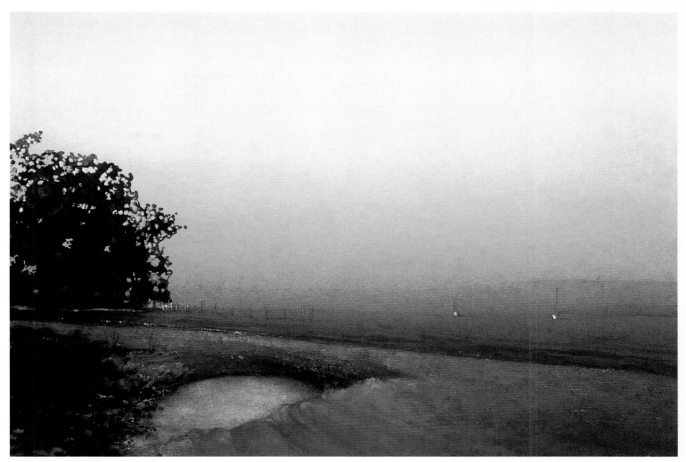

ON THE OTHER SIDE OF THE BAY
Watercolor on 300-lb. (640gsm)
Lana hot-pressed paper
21″ × 29″ (53.3cm × 73.7cm)
Private collection
Photo by Ron Zak

❧ *When I go outside, I cannot seem to focus on what to paint. When I do begin my painting, the next thing I know, I have no room left on my paper to paint what I really set out to paint. I am always running out of room. Do you have any suggestions?*

That is a good question, as it's happened to me many times. There is so much out there. Where do you begin, and how on earth do you fit it all on one little piece of paper? Make yourself a small mat (or buy one at the drugstore) with an opening of around 3″ × 5″ (7.6cm × 12.7cm) or smaller to frame a small area of something that interests you. An empty slide mount works well, or a camera viewfinder, if you happen to have one with you. Look through the opening as though you would the lens of your camera to find an interesting design and composition. When something excites you, that is when you begin your thumbnail sketch. Make a quick (five-minute) thumbnail sketch on a small drawing pad no larger than 3″ × 5″ (7.6cm × 12.7cm). Then you have your sketch down on paper and are ready to do your final drawing onto your good watercolor paper. Now you have a plan and can refer to your thumbnail sketch so you are not all over the place trying to paint everything in sight.

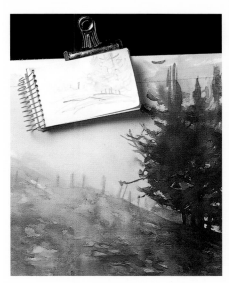

QUICK THUMBNAIL SKETCH

This is what the thumbnail sketch looked like for *One Foggy Day* (pages 82-83). Place your sketch above your painting while you are working, not on it as shown here. Use your thumbnail sketch as a guide—your plan and your goal—so you are not painting everything in sight.

How can I make branches look real? My branches have a tendency to look like sticks.

This is probably because you do not have a range of values in them. Look at a branch and study it. There is light hitting the branches from different directions—in the light, in the shadows. They are round, not flat. What gives the appearance of dimensional form? Value. This two-step demonstration shows how easy it is to create value with a piece of facial tissue.

Painting Branches

WHAT YOU NEED

- Watercolor paper
- Paints
- Raw Sienna
- Burnt Sienna
- Brush of your choice
- Palette
- Water
- A good supply of facial tissue

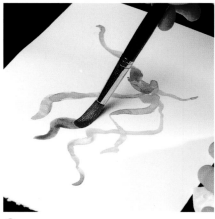

❶ BEGIN PAINTING BRANCHES
Mix some Raw Sienna and Burnt Sienna together, then load your brush. Making sure you have a piece of facial tissue in your hand, as well as some nearby, begin painting in your branches in many values.

❷ VARY VALUES BY LIFTING
While still wet, go in on top of a dark branch and blot with tissue. After you have lifted the paint, you have a lighter value on this branch, giving the branch form by varying values. While still wet, lift in *different* areas of the branches. Pay attention to where you do this so values are interesting. See the sun hitting the branch where you lift the paint with tissue, leaving dark in the shadows.

MUD ALERT!

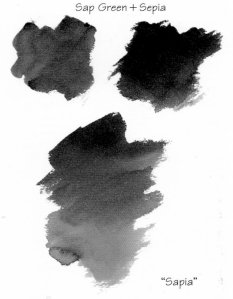

Sap Green + Sepia

"Sapia"

There are so many greens outside. When I mix mine, they all seem to come out the same color, making the landscape boring. Can you recommend some good greens?

Greens are a challenge for artists. When you are just beginning, you do feel limited and come up with some boring landscapes. Everything is the same color and value. To me, not one green out of a tube even resembles any green in nature. I mix my own. This is the trick. For example, you can mix Sap Green and Sepia to get a great green. Winsor Blue and Sap Green mixed together make another great green. I always used to mix blue and yellow and came up with the deadest looking greens you have ever seen, mostly ending up in mud because yellow is very opaque and muddies color in a hurry. It was a huge problem for me.

SAP GREEN + SEPIA = "SAPIA"
My favorite mix for rich greens is Sap Green and Sepia. You can get many greens from these two colors by adding more Sap Green, more Sepia or more water. My students call this color "Sapia." Years after my first watercolor class with Thelma Cornell Spain, I looked her up and called her. We had not spoken since I moved from the Midwest to California in 1982. She said she mixes her own green and that her students call her green "Thelma's green." I asked, "Is your green Sap Green and Sepia?" It was. I did not paint much after moving and was clueless how I came up with such a pretty green when I did paint again. I told her that all this time I thought I had invented that gorgeous green, and I thanked her.

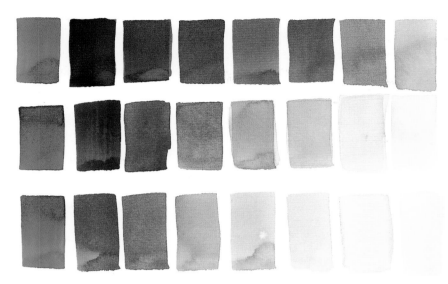

NEGATIVE SPACE

Negative space is the space around your subject. Whenever you are painting your subject matter, always pay attention to the shapes you are creating around the subject. If you only pay attention to the subject, your shapes around it could end up quite boring. The daisy on the left is boring. The leaves are almost exactly the same space apart and the same shape. The daisy on the right has petals of varied sizes, overlapping and more interesting overall.

TRY DIFFERENT MIXTURES

See how many rich greens you can come up with using Sap Green and Sepia. At the bottom of this chart, I also mixed Burnt Umber with Sap Green and then graded them down with water to show you some more luscious greens. Try a different green with Burnt Umber and grade it down with water. Mix one green with some pinks and reds, grading down the mixtures with water across the page. Always have just one green to a page and then add colors to that one, or one red on a page and repeat. Do you see how many colors you can create? Your landscape paintings will never be boring again if you mix!

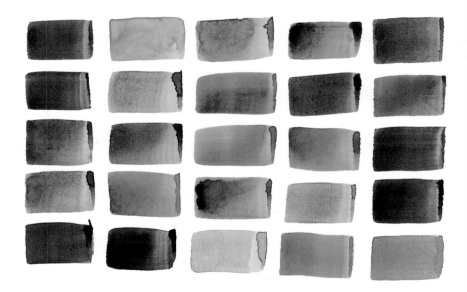

MORE RICH GREENS

Mixing other colors can create rich greens also. Take a sheet of paper and make a chart of your own, then pencil in what you have mixed next to the color. The last green in the bottom row (French Ultramarine Blue mixed with Cadmium Yellow Light and a touch of Sap Green) is the only blue and yellow I mixed together to get green. The various other colors I used were Alizarin Crimson, Rose Madder Genuine, Violet, Sepia, Thalo Yellow Green, Burnt Sienna, Aureolin, Yellow Ochre, Raw Sienna, Winsor Green (Blue Shade), Lamp Black and Ivory Black. Who would have ever thought you could use all these other colors to mix greens?

My trees look like green blobs. I cannot seem to get enough value in them to give them any kind of shape. I seem to get too deep in the mud and cannot get out again. What can I do to help this problem?

There can be many reasons for this. Maybe you are not mixing enough greens to vary them. You may be using too much yellow, which is very opaque and can turn into mud fast. You may need to add some interest to the shape of your tree, giving it shape and life and light to see through (tree holes) the tree. Also pay attention to the direction of your light source. In this case, the light source is the sun. There is nothing like getting the light on the right side of the tree and having the shadow going the other direction. Oh yes, it's happened.

Go outside and look at some trees. Study them. Some you can see through; others you cannot. Tree holes are where you see the light coming through the trees; they add interest to your trees. Put a couple in even if you do not really see any. It'll make a big difference, and your trees will not look like blobs. This is done with or without masking fluid.

NO VALUE RANGE

This uninteresting tree has no value range, and so does not have the appearance of dimensional form. It may be what our minds think we see when we look at a tree, but it is not what our eyes really see.

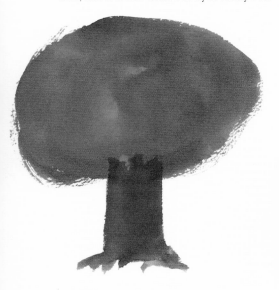

WHAT YOU NEED

- Watercolor paper
- Paint color(s) of your choice
- Brush of your choice
- Palette
- Water
- A good supply of facial tissue

❶ PAINT TREE SHAPE

You must know where your light source is coming from, even if it is not a bright sunny day. There is always some light hitting parts of the tree; in this case the light is coming from the left. See how the tree trunk is lighter on the left? Load up your brush with your color, and have a tissue in your other hand, as well as other tissues nearby. Paint in your tree, paying attention not only to making the shape of the tree interesting but also to the shape around it. Do not forget to leave some air for the tree to breathe, that is, leave some tree holes.

SET A GOAL

Decide how much time you will paint each day and commit to it! Record your painting hours if it helps you.

❷ LIFT OUT SHAPES

Again, be aware that the light is coming from the left. While your paint is still wet, crumple your facial tissue. Barely blot your tree to lift off some of the paint (the paint must be fairly dark for your lifting to show). Pay attention to these lifted shapes also because they are important to the form of your tree. Most of the right side of the tree is in the shadow, so it does not get much, if any, lifting at all. Do the same thing on the tree trunk. Play around with this technique. It's easy and gives you a value range by just lifting up paint with facial tissue!

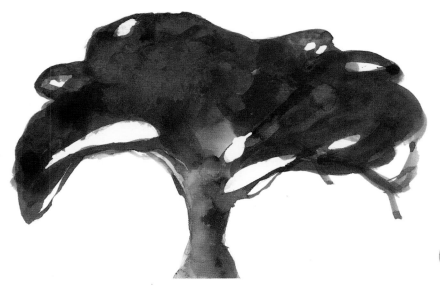

DON'T DO THIS

The tree cannot breathe and is a boring shape. Every blot is the same size and the same distance apart.

SUNNY DAY SKY
French Ultramarine Blue, Winsor Green and Winsor Blue

SUNSET SKY
Raw Sienna, Aureolin and Yellow Ochre

SEMICLOUDY SKY
French Ultramarine Blue, Sap Green, Yellow Ochre and Rose Dore

SOFT HAZY SKY
French Ultramarine Blue, Yellow Ochre, Jaune Brillant #1 and Rose Dore

My skies look boring. What do you recommend for different weather?
I have painted four skies at left depicting several moods. To create an atmospheric look, use graded washes. Wet your paper first. While the paper is wet, all the colors go on one at a time. Add different colors to your skies. Brushstrokes cross at a slight diagonal, to add interest. Be careful not to overwork. When you wet the paper first, you can also leave some dry spots. In doing so, you will get a few hard and a few soft edges from the wetness of the paper.

I am trying to make softer-looking clouds. Can you help me?

LIFT OUT CLOUDS
Wet your entire sheet of paper with a wash brush and clear water. With a tissue in one hand and the right size wash brush (depending on the size of your paper) in the other, wash in color (I used blue) with a slightly diagonal movement from one corner to another. Working quickly, before the paint dries, crumple the tissue and blot with it, barely touching the paper. Lift, add colors, lift again until you get the look you want. Do not overwork. If you want more color, let your paint dry. Wet the paper again, add more color and repeat the technique.

DON'T DO THIS
This is an example of what happens when you pay attention to your larger shapes while blotting but do not blot smaller shapes fast enough. The paper was much too dry to lift off the paint by then. You have to work quickly. As soon as you put that paint on, you should begin your lifting. Put the paint down, lift and pay attention to your shapes all at the same time!

DON'T DO THIS EITHER
When blotting and lifting off paint to make your clouds, do not make them all the same size and distance apart. It's very boring.

How do I make water look like water?

If you stare at water long enough, you will begin to see definite shapes. If you focus on these shapes, you will be able to capture the essence of a particular body of water. Remember to paint reflections of the sky in water. As above, so below.

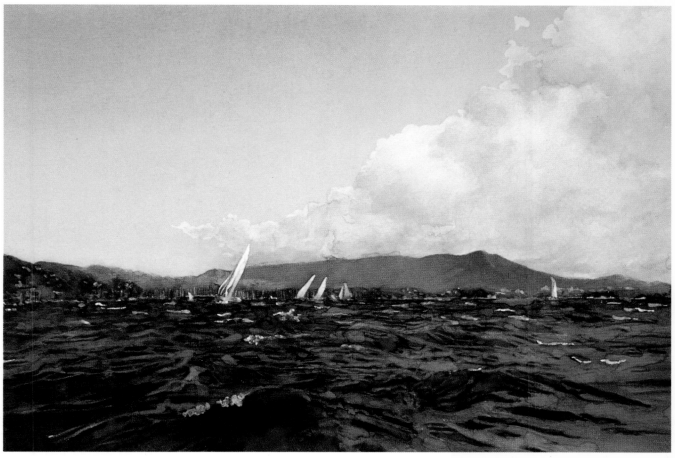

SHAPES, MOVEMENT, REFLECTIONS

When you stare at water long enough, you begin to see shapes. I approached the water in this painting in this manner. See how the pink clouds in the sky reflect in the water?

OPENING DAY
Watercolor on 300-lb. (640gsm)
Lana hot-pressed paper
15″ × 22″ (38.1cm × 55.9cm)
Private collection
Photo by Ron Zak

▲ EL TRANSPARENTE
Eric Michaels
Watercolor on 90-lb. (190gsm) Aquabee Super
Deluxe paper
5″×11″ (12.7cm×27.9cm)
Collection of the artist
Photo by Dan Morse

FINISHED STUDIO PAINTING ▶

This is Michaels's larger studio work based
on his sketch. "Lacking information and
details, I began working wet into wet and
allowed the paint to dictate such things as
carvings, sculptures and other architec-
tural forms. . . . The figures were added
for scale. Although the finished painting
might be challenged by an architectural
purist, I feel it maintains . . . my emotional
response to the original scene."

EL TRANSPARENTE
Eric Michaels
Watercolor on 140-lb. (300gsm) Royal Watercolour
Society cold-pressed paper
30″×16″ (76.2cm×40.6cm)
Collection of the artist
Photo by Dan Morse

*Is it possible to take the essence of what one sees and feels on location
and expand that in the studio?*
With rare exceptions, I find that studio paintings lack the freshness and
spontaneity of works executed directly from life. However, it is possible to
capture the essence of a subject by working directly from an on-location
watercolor sketch, as seen in Eric Michaels's sketch (at left) painted on
location in Toledo, Spain. He elected to paint from his sketch back in his
studio in Santa Fe, New Mexico.

❧ *How can I capture the feeling of a place?*

The first thing you can do is to identify what caught your heart. Ask yourself how you can describe those feelings with design and pigment. What is it that moves you? When you figure that out, you have a direction and can design a painting. Leave out what doesn't help express that feeling.

WARM AFTERNOON LIGHT

This painting emphasizes warm afternoon light, achieved by staining the paper first with a light yellow wash to eliminate any white. The warm yellow glows through all of the colors painted on top of it, with warm color used everywhere but the shadow areas. Libby Tolley connected the tree shapes to create larger shapes, and kept the mountain shapes simple to create a restful feel. The buildings are the focal point, with more activity and contrast (both color and temperature) in these smaller shapes. Libby comments, "I love to paint on location. My goal is to make a painting that reflects the sense of place as I experience it using color and design to convey my thoughts. Some of these paintings are transparent and others are not. If I lose the lights, I do not stop—I add gouache to the palette and continue on the journey. Often I will start a painting on location and then finish it up in the studio. I go the distance with the painting, not stopping until I have completed the journey. From my plein air work, I develop a sensitivity that helps my studio work."

AUTUMN AFTERNOON
Libby Tolley
16" × 20" (40.6cm × 50.8cm)
Watercolor and acrylic on 140-lb. (300gsm)
Arches rough paper
Private collection
Photo by Peter Mounier

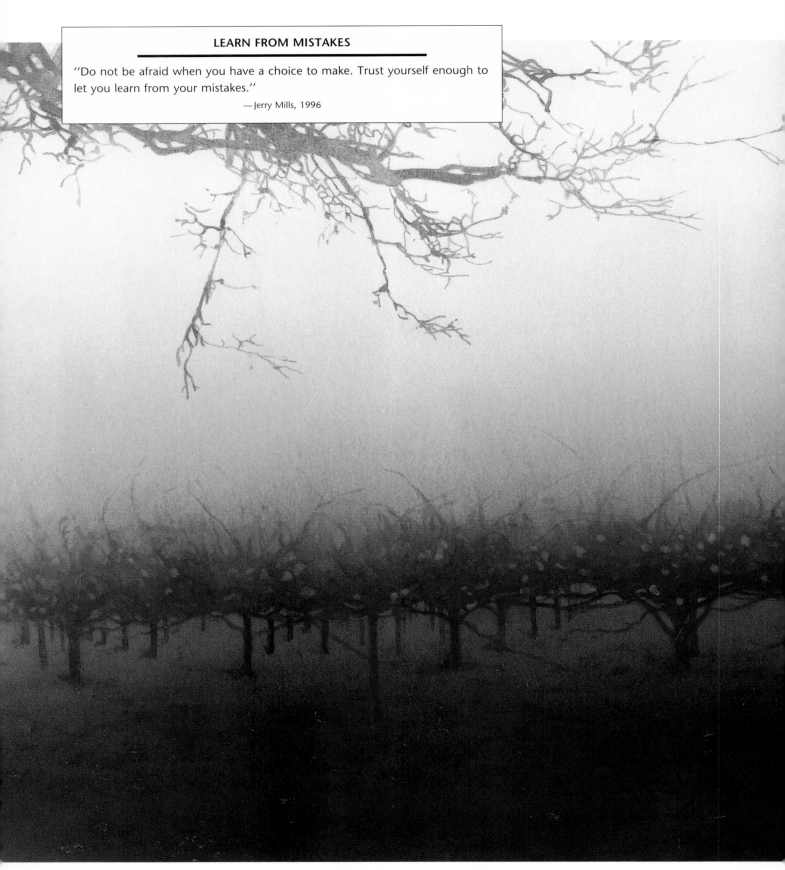

LEARN FROM MISTAKES

"Do not be afraid when you have a choice to make. Trust yourself enough to
let you learn from your mistakes."

—Jerry Mills, 1996

HEAVEN AND EARTH
Watercolor on 300-lb. (640gsm) Lana hot-pressed paper
21" × 29" (53.3cm × 73.7cm)
Private collection
Photo by Ron Zak

Is This a Mistake or a Creative Opportunity?

Someone once asked me, "How do you do all these paintings?" She told me that she had a studio set up in her house for two years but she could not go in there and paint. I asked her, "Why?" "What if I make a mistake?" she said. I took her one step further and said, "What if you do?" She could not think beyond her fear of making a mistake.

When we were little, making a mistake was shameful. So we strove to be perfect. We worked so hard at it that pretty soon we would do anything to avoid making a mistake. The fear of making a mistake is deep for many of us.

I have come to welcome mistakes and not be afraid of them. With watercolor, it's difficult to change things once they are on the paper. Have faith. You can fix just about anything. Mistakes are creative opportunities that allow us to grow and learn. I have made so many errors and learned so much just painting on my own and working them out myself. For me, this is when the challenge begins.

Fears of making any kind of a mistake can keep us frozen, never moving ahead or risking anything. It is more safe and comfortable to stay with the things we know. As a beginner, you will have many fears and make numerous mistakes. If you know and expect this now, you *will* make it into your studio and begin painting.

All of the paintings you see in this chapter are the result of creative opportunities that arose from mistakes. Some of them are before-and-after paintings—what I did not like and what I did to go back in and improve paintings. There are some paintings in which nothing went wrong at all, but there are important lessons in them.

Mistakes are gifts. Welcome them. Trust that little voice that asks, "I wonder what would happen if?" Go for it! Risk! Feel the joy and confidence that happens to you when you trust in yourself. Push through your fears and mistakes. You will be able to take more risks and create more opportunities.

BEFORE **DRAB DESERT**

This was a painting of a desert. The galleries did not want it, and I could not sell it at festivals. I used the frame for another piece. I hated the piece. I was afraid to darken the bottom and take that risk. One day, my framer, Robin, said to me, "What do you want to do with this piece?" I forgot it was even at her shop. That's how much I loved the piece. I did not even know where it was. When I looked at it I knew there must be something I could do. "Give it to me," I said, "I am going to put in a sailboat in water at sunset."

FACE YOUR MONSTERS

Fears are your inner critics. We all have them, no matter what you call them. They keep you from doing anything that is nurturing for your soul, like your art. They tell you what you should or should not be doing. They tell you that you cannot paint. They are waiting in the wings for you to make a mistake. When you do, they nail you, telling you that you are no good, you cannot paint, why did you even think you could, let alone sign up for this class? They are relentless! You are putting your heart on the line and it's tough. If you are not making mistakes, you are not learning. Mistakes are good.

If you are always afraid of making a mistake, ideas will stay in your head forever and never make it near a paint brush or piece of paper. You could attend ten workshops a year, go home and do nothing with all the techniques you learned because you are afraid of making a mistake.

You will meet these inner critics and have to confront them. It is just as important to work with them as it is to learn the medium of watercolor, particularly if you are a beginner or cannot seem to get in there and paint. You do want to get in there and paint, right? It's all a part of the artist's process, as well as life's process.

When you confront these inner critics, you become more confident in yourself. There is no room for fear, only faith. When you believe in yourself, the monsters go away. They have no fun picking on a person who is confident and strong.

AFTER **STUNNING SEASCAPE**

I was not sure but had to try. It sure sounded good. No fear anymore. There was nothing to lose. I knew it could be something someday. I masked out the boat, sun and waves. I worked the waves into a design with masking fluid right on top of the original painting. Next, I added many graded glazes of darker colors, at the bottom where the masking fluid was. When I peeled off the masking fluid, these darker glazes made the boat, sun and waves lighter than the rest of the painting, creating shapes in the water and adding much more interest. The lights in the water, the boat and the sun were lighter because I protected them with masking fluid. A direct painting approach would have been to just paint in the boat, waves and sun, with no glazes. Just paint on top of paint. There is nothing wrong with that way of painting. I often paint that way. That would have been interesting also—gouache or acrylic. This one needed a great amount of interest, so this was my plan of attack. I amazed my framer when I brought it back for framing again and she saw what I had done. And it sold.

WISHING YOU WERE HERE AGAIN
Watercolor on 300-lb. (640gsm)
Lana hot-pressed paper
21" × 29" (53.3cm × 73.7cm)
Private collection
Photos by Ron Zak

CHANGE YOUR THINKING

When things are not going your way in a painting or you simply do not know what to do with it next, put the painting in a pile. Begin your pile now. Don't ever throw a painting away.

Once in a while, something in your pile will spark your interest again or you will look at it in a new way and know how to make it work. Take it out of the pile and work on it fearlessly. You have nothing to lose and everything to gain!

From now on, when you make a mistake, begin to turn your thinking around. Ask yourself, "What can I do to make it work?" Keep going if you can figure out what to do. Do not throw it in the trash. Put your painting aside if you really do not know what to do or your heart is just not in it anymore. Begin a new piece. One day you may go back to it and know what to do, but always make sure your heart is in it.

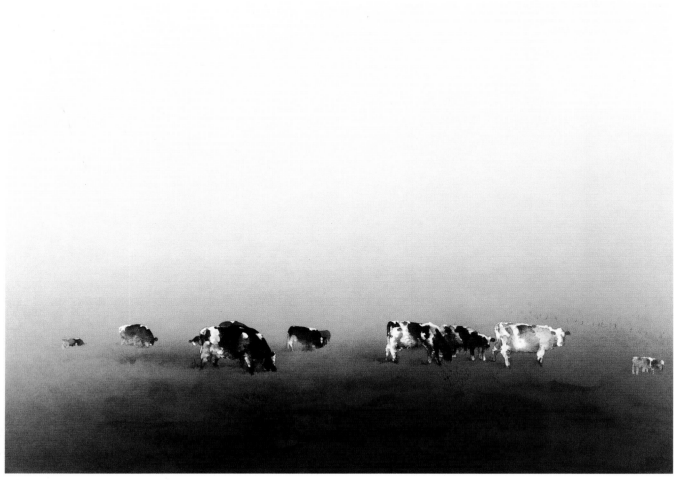

BEFORE BORING

This painting was OK, but extremely boring! It needed something, but I had no clue what, and my heart was not in this one anymore.

NO-PRESSURE PAINTING

If you want to practice your skills in watercolor, get out your pile of old, unfinished paintings. See what you can do to make them better. You may surprise yourself. If you tell yourself it's only a practice painting, there's no pressure! You become more relaxed and not so determined to "get it right" or not so afraid you'll make a mistake. You didn't like that painting anyway! You have nothing to lose, and you may just recover the painting you used to hate.

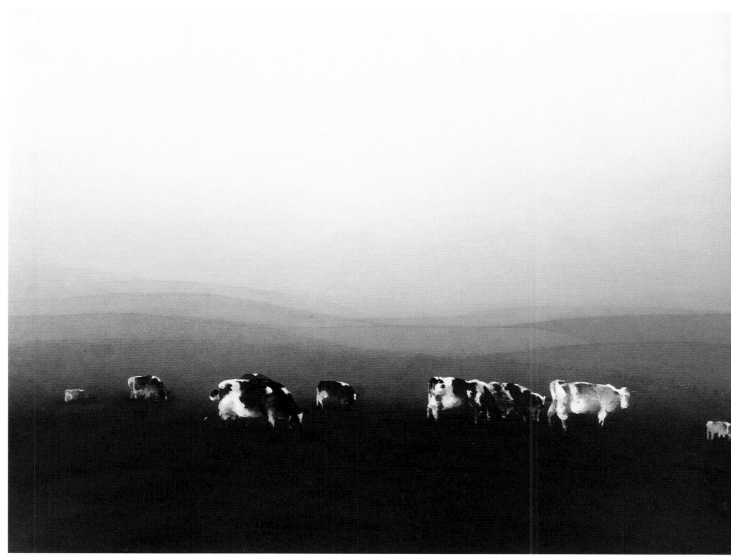

AFTER BETTER VALUE RANGE

One day I realized that making the foreground darker would make the piece stronger. I masked out the cows and glazed over them with darker colors. The hills were not part of my plan. They happened on their own. As they kept going off into the distance, I kept going off into the distance. I went with them. I had a plan for this painting but somehow the piece had a plan of its own. Flow with things instead of resisting them when things like this happen.

A MOMENT OF STILLNESS
Watercolor on 300-lb. (640gsm) hot-pressed paper
21″ × 29″ (53.3cm × 73.7cm)
Private collection
Photos by Ron Zak

ASK YOURSELF THIS

What is the feeling I want to convey? When I see beautiful watercolor paintings that are technically correct, I often look at them and think of all the rules the artist followed, but I feel no emotion. Emotion and feelings are the most important ingredients in a painting. When you learn the medium and you forget the rules (because there really are none), your emotions may just show up in your paintings, if you let them.

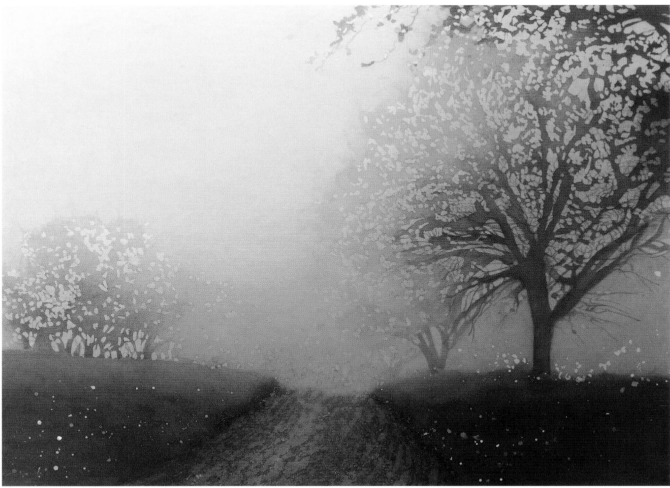

BEFORE WEAK

After a show rejected this piece, I decided to do some more work on it. I knew I could make it stronger.

LEARN FROM REJECTION

A show rejects one of your pieces. You know it was the best watercolor you have ever painted. You walk in circles, saying, ''I don't get it.'' Do not waste one more minute trying to figure out any rejection. Different judges look for different things. Look at the piece for a while and study it. Sometimes, I'll learn something from a rejected painting and understand why it wasn't good enough. Other times, I know it's good, so I leave it alone.

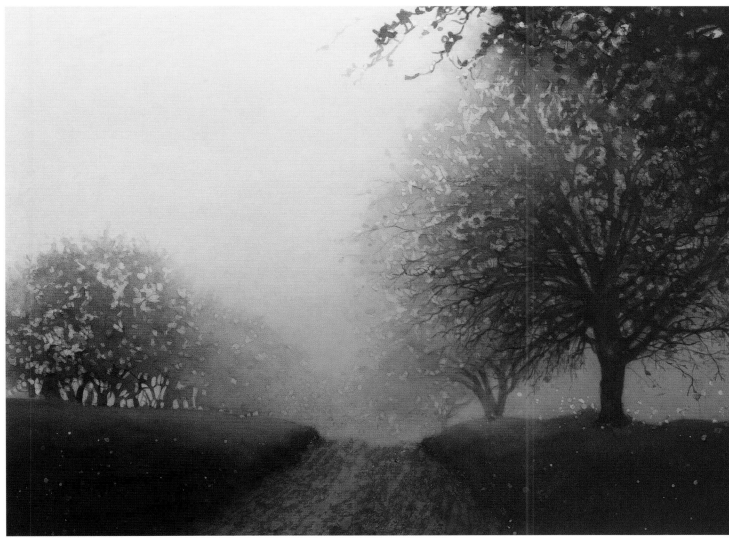

AFTER **BETTER VALUE RANGE**

I did several more layers of washes, darkening the values in the trees and distant fog. This painting won an award at the Triton Museum of Art in Santa Clara, California. This is the driveway to my home, lined with walnut trees.

A SENSE OF PLACE
Watercolor on 300-lb. (640gsm) Lana hot-pressed paper
21″×29″ (53.3cm×73.7cm)
Private collection
Photos by Ron Zak

TAKE SOME CHANCES

Make every painting a challenge. Sometimes we get into a very comfortable and safe place with our work. When we do, there is no challenge and we keep painting the same kind of paintings. One right after the other. How boring. What are you learning? Safety or watercolor? You must take some risks in order to grow.

BEFORE UNFINISHED LOOK

I had been telling a friend how awesome this piece was. I could not wait to show it to him. He looked at it and said, "Are you finished with it?" Now, you know you are in trouble when someone says that to you. First of all, I am extremely careful what people I let into my studio, and rarely show works in progress. When it does happen, I stay open to comments and critiques. I will study the piece and think about it. Sometimes the piece does need more work; sometimes it does not. Work on something only if you think it needs it. Never go back in because of someone else. You could line up one hundred people and they will have one hundred different things you should change on the piece. Listen to your own feelings, not to anyone else.

MISTAKES ARE GOOD

Don't give up when you make a mistake. Reprogram your thinking. Turn your thinking around. Say to yourself, "What can I learn from this?" Start looking at your mistakes as something good, not bad. Take action. You'll grow by leaps and bounds! Mistakes happen, in watercolor and in life. It's how we choose to look at them that makes the difference. At least you are having fun painting. Mistakes can work for you! They are gifts!

AFTER **BETTER COLORS**

Masking out the sun again, I began glazing with many bright and unusual colors, experimenting. I could not even tell you the names of them all. None of them made sense, but I listened to my intuition. At the time, I had to scrub out something that happened at the horizon line. You really cannot do that too well on a smooth wash piece. I used an oil brush! I thought I had hidden the scrub marks pretty well with a thousand more washes. Then a student came in for class. He immediately said, "What's that you scrubbed out there?" So I added more glazes and colors, and finally there was no more scrub marks.

NOTHING IS ALL
Watercolor on 300-lb. (640gsm) Lana hot-pressed paper
21″×29″ (53.3cm×73.7cm)
Private collection
Photos by Ron Zak

SEE THE WHOLE PAINTING

Step back from your painting frequently (every ninth brushstroke, I've heard) to check on the entire composition. Work all over it so you get a sense of what the whole thing will look like. Working in one little patch at a time doesn't allow you to see the whole painting.

BEFORE **WIMPY**

This was a little wimpy. I needed to deepen the values, make the shapes more interesting and darken the shadows.

REJECTION ISN'T A SETBACK

It's OK. Accept it. It is going to happen. You don't like every piece of artwork out there either, do you? You win some and you lose some. It's that simple. Yes, it would be just wonderful if we got into every juried show we entered. But we won't. Sure, it hurts, but it gets easier. Try again, try harder, learn more and keep going! Don't be discouraged and stop. Do another painting, or enter your beauty in another show with a different jurist. My father said to me once, "If you're not making mistakes, you're not doing anything." If you aren't painting, you won't even get as far as rejection.

AFTER **BETTER SHAPES, COLORS AND VALUES**

I went in fearlessly, paying more attention to the cow shapes and colors, darkening shadows.

I'M GONNA LOVE YA TILL THE COWS COME HOME
Watercolor on 300-lb. (640gsm)
Lana hot-pressed paper
21" × 29" (53.3cm × 73.7cm)
Private collection
Photos by Ron Zak and Jerry Mennenga

LEARN MIND TECHNIQUES

Don't be afraid of making a mistake or taking a risk. Quiet your mind to not think about paying the rent, or what else you "should" or "could" be doing. Fight your demons or monsters. How many workshops have you been to when you went home all jazzed up, yet never did a thing? Why? Because you hadn't learned these mind techniques yet. That's all. They take time and practice. Learn to believe and trust in yourself.

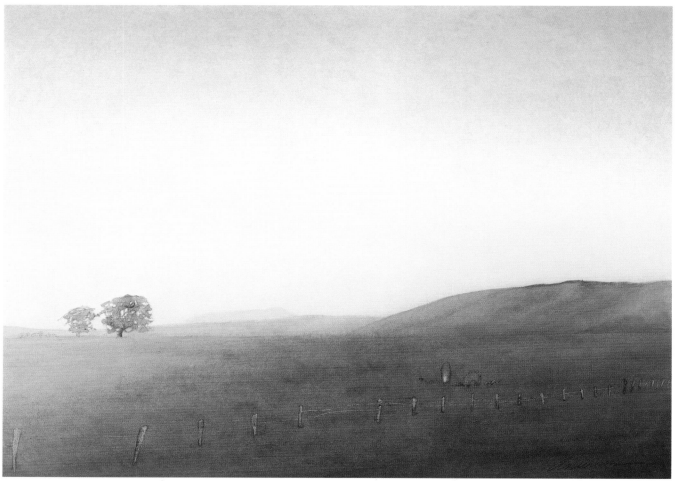

BEFORE INK-BLOTTER EFFECT

This painting is boring. I was trying out a new paper with less sizing in it than my usual paper. There was no sizing on the paper, and before I knew it I had to stop. When you lose your sizing, your paint absorbs into the paper immediately. You have no control of your paint as you watch it absorb into the paper and your cow is getting larger and larger (ink-blotter effect). You cannot push around colors the same way you can when the sizing is in the paper. I learned that different brands of watercolor paper have different amounts of sizing in them. Remember that. Because the paper would not take any more paint or water, I put this painting in the pile. My heart was not in it.

KEEP THE FAITH

Never lose sight of your dream, no matter what you want to do in your life. Never.

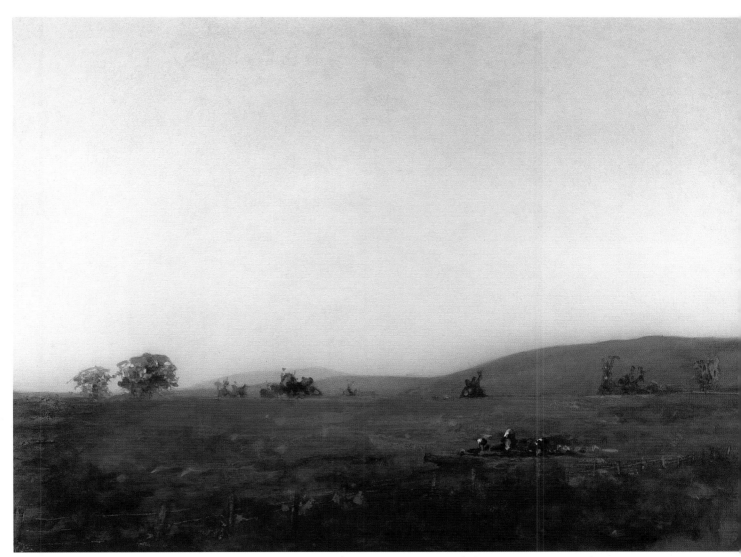

AFTER OPAQUE COLOR

Transparent paint does not work well on an ink blotter. The only solution was to go in and attack it with heavy opaque paints. The paper would only accept a heavier paint with very little water. It certainly needed more color. I squeezed watercolors right out of the tube, as well as gouache, acrylic and Aquacryl paint by Lascaux. If anything, I had more fun working with these different mediums, breaking through some boundaries. Experiment with opaque paints.

CALIFORNIA SUMMER
Watercolor on 300-lb. (640gsm)
Lana hot-pressed paper
21" × 29" (53.3cm × 73.7cm)
Private collection
Photos by Ron Zak and Jerry Mennenga

CHECK YOUR PROGRESS

When you find a size of paper you are comfortable working on, have an inexpensive mat made for that size. Get mats cut to fit a full sheet, half sheet and quarter sheet to have on hand. Every so often put a mat over your painting. It helps frame your painting so you can look at it and see if you are heading in the direction you want to be. It's also helpful to hold your painting up to a mirror once in a while. If there is something wrong with it, the problem will usually pop out at you right away.

BEFORE UNDEVELOPED VALUES

On page 11 I tell a story about a disaster I had with mold on paper. *Greenpiece*, left and below, was one of the pieces that had this problem. The mold was along the top. I cropped off about 4 inches (10.2cm). Everyone loved it! I never really did. It did not feel finished, but I feared going back into it and having more mold appear! A show rejected it, it came back from a gallery and it even sold once and came back! It made it to the pile.

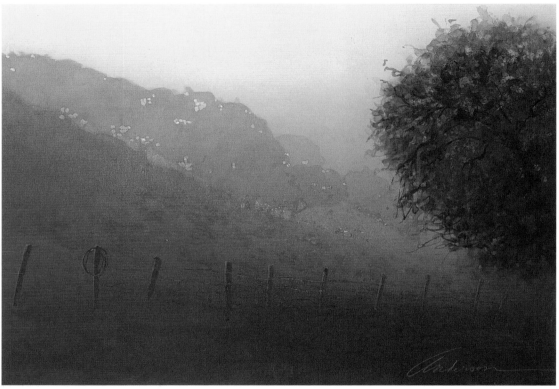

GREENPIECE
Watercolor on 300-lb.
(640gsm) Lana hot-
pressed paper
18" × 29"
(45.7cm × 73.7cm)
Private collection
Photos by Ron Zak

AFTER BETTER VALUES

By now I had nothing to lose on this one. I went back into it. I began glazing all kinds of colors over the entire painting, grading washes darker toward the bottom. I then attacked that wimpy-looking tree on the right and made the others more interesting. I was fearless. If I ruined the painting, fine. I was sure there would be a good lesson there for me, in any case. The tree now looks as though it is rooted into the ground and going to live. It's not off in space somewhere and feels a great deal stronger to me. After I finished it, I shipped the painting to my gallery in Santa Fe and it sold immediately for thousands of dollars. I knew I had the courage to go in there with those darks and make that painting look like one of my favorite country roads near where I live. It did not feel like one of my favorite places the first time. Now it does.

RESCUING THE GOOD PART

If you have a painting that you only like portions of and do not want to discard the whole thing, have several sizes of inexpensive mats cut. Put one of the mats on top of the parts of the painting you like. Move it around to other areas on the painting. It may surprise you how many paintings you will find out of that full sheet you were going to throw away. If one mat doesn't work, try another size.

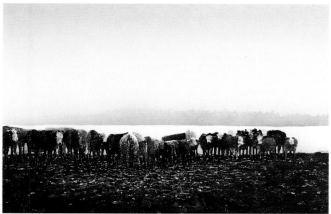

BEFORE DRAB WINTER COLORS

This painting just sat, and I wondered what I could do to improve it. It went into the pile.

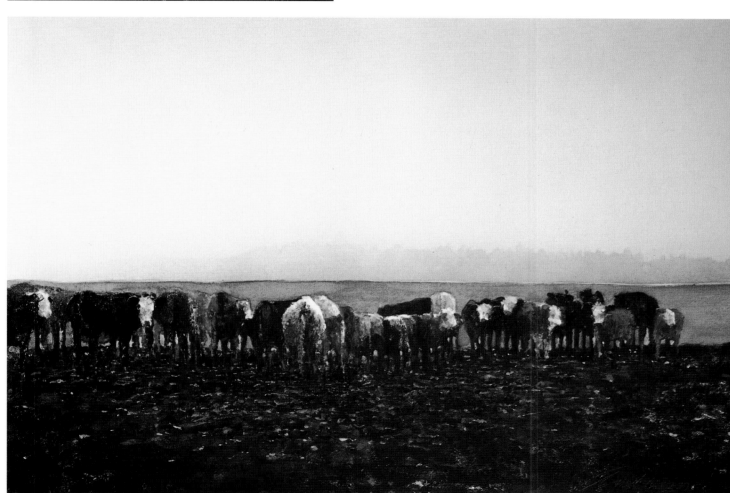

AFTER LIVELIER SPRING COLORS

It screamed for more color. After I masked out the whites and lighter areas that I wanted to keep, I glazed many different colors of greens, pinks, blues and siennas. When the masking was completely dry, I peeled off the lighter areas and went in with some detail on the cows, and soon there was spring!

JAMMIN
Watercolor on 300-lb. (640gsm) Lana hot-pressed paper
10″×21″ (25.4cm×53.3cm)
Private collection
Photos by Ron Zak and Jerry Mennenga

TIME FOR WATERCOLOR

Protect your painting time. It is very precious. Sacred.

BEFORE MISSING SOMETHING

I was at a workshop and should have brought references, such as photos. I had a picture of my dog, Yuki. I painted her and thought the painting was awesome at the time. As I learned more and more about working from photographs, I began to realize how "dead" the painting really was—no life, color or interest. The most important ingredient was missing—her beautiful spirit!

YEW-KEY, YOU DAWG! ▶
Watercolor on 140-lb. (300gsm)
cold-pressed paper
11"×14" (27.9cm×35.6cm)
Collection of the artist
Photos by Ron Zak and Jerry Mennenga

◀
YEW-KEY, YOU DAWG!
Watercolor on 300-lb. (640gsm)
Lana hot-pressed paper
15"×22" (38.1cm×55.9cm)
Collection of the artist
Photos by Ron Zak and Jerry Mennenga

AFTER SPIRITED ACTION

Two years after the first watercolor of Yuki, I had learned more about working from photographs. I decided to put some more life into a painting of this wonderful dog, with a little more action. One day the backlighting was perfect on our walk and I had gotten some great action shots with my camera of her coming at me. I captured the action, added more color and, most of all, her magnificent spirit. When you know and have a passion and love for someone or something, it often shows in your painting. When working from reference photographs, pay attention to making sure your painting has some life and energy, particularly if the photo does not have much. You do not have to take your references so literally. You do not have to put everything that's in the photo into your painting. You can even add things, if need be. Use photos for reference only. Translate them into what you want on your paper. It's your painting! Remember, you are the creator. Leave out anything that is not going to work well in your painting.

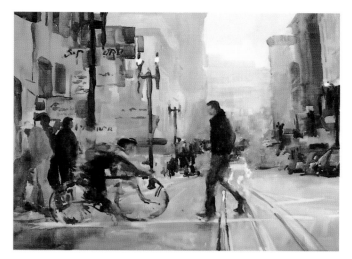

Sally Cataldo comments, "This painting was a very quick, spontaneous painting. I liked it the way it was and the composition was OK. There is a tension (push-pull effect) of the walking figure going to the left and the figure on the bike going right. Vertical buildings add more contrast to the horizontal group of figures. I was still searching for something more. The effect I was looking for was of more mystery and overall darker value, with more lost and found edges."

AFTER BETTER VALUES

"I went over the entire painting with dark glazes of French Ultramarine Blue, Burnt Sienna, Permanent Rose and many more darks," Sally says. "The results were more of what I was after. Even though you can still make out the figures, the car lights behind the figure walking across the street add more interest to the right side, and balance out the painting."

CALIFORNIA STREET
Sally Cataldo
Watercolor on 140-lb. (300gsm) Winsor & Newton cold-pressed paper
22″ × 30″ (55.9cm × 76.2cm)
Private collection
Photo by Michael Smith

SHARE YOUR GIFT

Art is a gift. Share it and good things will come back to you!

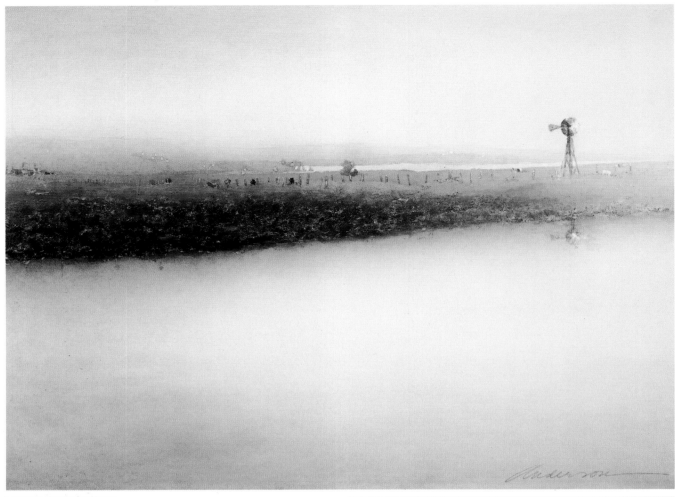

BEFORE UNINTERESTING

This one needed a little toning down. I felt it looked a little too neon. There was nothing really happening in the water. It needed more colors and more interest. I also wanted to bring out the strip of water in the background.

ENJOY THE ADVENTURE

Sometimes your painting will not be what you had planned. It may take on a life of its own. At first you panic. It's not what you planned. Relax and go with the painting! It's an easier road to take. Never fight with your painting. Be open and flexible. It's just the "Oh-my-gawd" monster telling you that you're out of control. Get out of your own way. See where your painting will take you. Enjoy the adventure!

AFTER MORE MOVEMENT

I painted more opaque colors in the sky and water. The water has more movement and some reflection from the sky, yet it's calm. I grayed down the green a great deal too.

Softly Remind Me
Watercolor on 300-lb. (640gsm) hot-pressed paper
21" × 29" (53.3cm × 73.7cm)
Private collection
Photos by Ron Zak and Jerry Mennenga

MAKE THE COMMITMENT

Some of the most wonderful, unplanned things have happened to me as an artist. Commit to your work 200 percent. Get your work out there and then let it go!

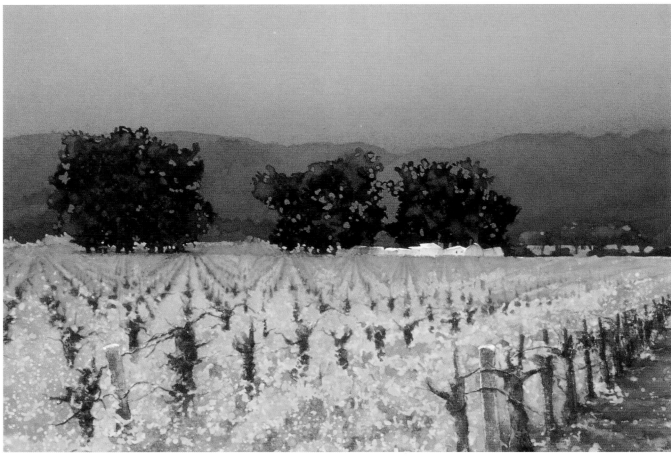

FIELDS OF GOLD
Watercolor on 300-lb. (640gsm) hot-pressed paper
21″ × 29″ (53.3cm × 73.7cm)
Private collection
Photo by Ron Zak

INNER CRITICS

"On the journey of self-discovery, let us stop looking for what is wrong with us. Let us discover, instead, who we are and how we work! Let us put our judgment aside as we explore the amazing system of selves within us and learn to live with ever increasing honesty, choice and freedom."

—Hal and Sidra Stone,
Embracing Your Inner Critic

JUST KEEP PAINTING

This piece had at least one hundred washes in the sky and the mountains, and I hated it. I had masked off the bottom to protect the field of mustard from the darker colors I was glazing on the top. The top was dark and the bottom was the white of the paper when I peeled off the masking fluid. I remembered my teacher telling us we should work all over the painting, not in just one little area, so that we would get a sense of the entire painting as we worked. Then I heard her voice, "Just put the trees in and see what happens!" I did and began to like it. Not love it. Like it. Next I began masking the mustard field in layers and layers, spattering masking fluid in the field, letting it dry, putting washes over the entire paper in all sorts of colors. When dry, I peeled off that masking, spattered another layer of masking fluid, added watercolor and kept repeating this process.

Since I wet the back and front of my paper when I do washes, the fibers are very soft. So when I went to peel off the masking in one of the stages, the paper came with it in big chunks. The top was dry, but this is when I realized that the entire sheet must be thoroughly dry before you peel off your masking fluid. Now what?

I drew the vines and mustard field design back in, working on the paper where it had torn off in sections and spattered more masking fluid, working it into the rest of the painting. It made some very interesting textures. You could not even tell.

When the century-old vines went in, I was in love with it.

ANY DREAM WILL DO
Watercolor on 300-lb. (640gsm)
Lana hot-pressed paper
21″×29″ (53.3cm×73.7cm)
Private collection
Photo by Ron Zak

LEARN WHEN TO STOP

A breakthrough occurred on this piece. I learned when to stop. I experienced that feeling inside when you know a painting is finished. I had begun working on the painting, looking at it, questioning. How do you know when to quit? How do you learn to leave that *one* brushstroke alone? You went back in to try to make it better and it's all over now. At times you just know; at other times you do not. A person with confidence knows when to stop.

I thought I had another week of work left on this piece. After putting on another blue wash, it was never so clear to me that a piece was definitely finished.

WORK WITH IT

The night I moved into my new home in the Napa Valley, my favorite cat died. I had this painting half finished, with masking all over the afghan and the cat, for years. I could not finish it. One day I decided to finish it so I could look at her up on the wall, not in the pile.

Out of the pile it came. By now the masking fluid had "baked" into the paper while sitting in the pile (not in direct sunlight). The masking fluid would not come off, even though I tried to rub it off with anything I had in that studio. I decided to work with the baked-in masking fluid. This is not an easy task, as masking fluid resists paints, so I had to go in with darker colors in the afghan and various other spots, darker than the baked-in masking fluid color. The masking peeled off the paper in splotches, but I worked those white patches into her fur. I used white gouache to bring out some whiskers and textures.

PRINCESS
Watercolor on 300-lb. (640gsm) Lana rough paper
15″×22″ (38.1cm×55.9cm)
Collection of the artist
Photo by Ron Zak

HAKUNA MOO-TA-TA ▲
Watercolor on 300-lb. (640gsm) Lana hot-pressed paper
21″ × 29″ (53.3cm × 73.7cm)
Private collection
Photo by Ron Zak

LOOK, STUDY, THINK, ENJOY

I saved whites with masking fluid, then, after one hundred glazes, went in and worked on the cow details. The top of the paper was dry, but underneath it was still wet, although it did not feel wet. When I peeled off the masking, the paper came off in patches.

I worked the blacks into where the paper had peeled. I did not resist or go against the shapes of the torn paper. When you're faced with a challenge, whatever flows effortlessly is usually the best thing to do.

When facing catastrophe, spend some time with your painting; look at it, study it and think about what caused the mistake to happen. See how you can solve the problem. This is a creative opportunity. Do you see?

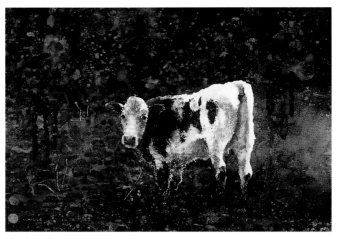

NOTHING BUTT THE COW ▲
Watercolor on 300-lb. (640gsm) Lana hot-pressed paper
11″ × 14″ (27.9cm × 35.6cm)
Private collection
Photo by Ron Zak

HAVE A BALL

This painting had three cows in it originally. After fussing with the painting, only one looked halfway like a cow. I had no choice but to wipe out the ones I did not like. In order to do this though, I had to go really dark. They finally disappeared after many layers of dark colors.

I had so much paint on the painting then, to cover up the cows. When I accidentally dropped some water on the green background and went to lift off the "spill," it left the most interesting design. I had a ball working with those designs, spattering more, lifting the paint, adding more colors, spraying. Another "happy accident."

HELLO ▲
Watercolor on 300-lb. (640gsm) Lana hot-pressed paper
21″ × 29″ (53.3cm × 73.7cm)
Private collection
Photo by Ron Zak

DON'T LET ON

This is a painting of two goats. Really. I kept fussing with that white goat's mouth but could not get it right. I figured I had better stop before I totaled the thing. It was OK, I kept telling myself.

Then I had an open studio one weekend. The painting was hanging where people could see it when they first walked in the door. Everyone immediately asked, "Is that a pig or a goat?" I'd say, "Well I screwed up the nose on the white goat, but sure had fun painting it!"

A friend called me aside. "We need to have a little talk," she said. "Don't tell anyone you screwed up the mouth! The next person who asks about it, let them think what they want." Within five minutes, someone came in and said, "My mother would love this painting. She used to raise pigs!" She bought the painting.

PUSH YOURSELF

I took a workshop with Katherine Chang Liu a while ago. She said, "You are too labor intensive Catherine. You could do those paintings with only seven glazes!" Boy, did that scare me. I decided because it did frighten me that I would work on that in the workshop that week. That's why I was at the workshop anyway—to push through some boundaries. The painting you see here has around fifteen glazes. It was a breakthrough painting, even though I used more than seven glazes. I did not have the hang of it yet. The teacher was honest and knew I needed that push. She challenged me and it worked.

Morning Has Broken
Watercolor on 300-lb. (640gsm)
Lana hot-pressed paper
21″ × 19″ (53.3cm × 48.3cm)
Private collection
Photo by Ron Zak

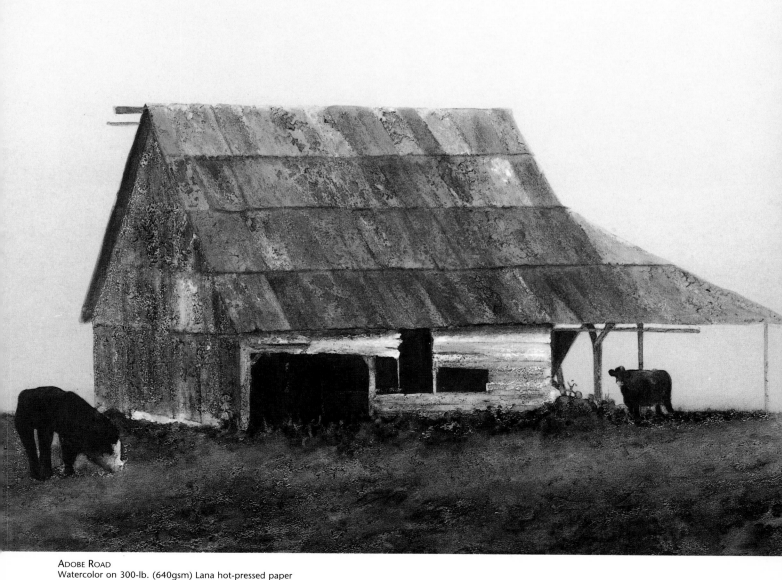

ADOBE ROAD
Watercolor on 300-lb. (640gsm) Lana hot-pressed paper
21″×29″ (53.3cm×73.7cm)
Private collection
Photo by Ron Zak

Contributing Artists

The following artists have given permission for reproduction of their art in this book.

Sally Cataldo
Santa Rosa, California
California Street (San Francisco)
© Sally Cataldo

Len Clark
Upper Montclair, New Jersey
Cartoon © Len Clark

Serge Hollerbach
New York, New York
Simple Elegance (*Springmaid Beach*) © Serge Hollerbach

Judith Klausenstock
Tiburon, California
Cherry Jam and *Five White Squash*
© Judith Klausenstock

Frank LaLumia
Santa Fe, New Mexico
Fog at Two Harbors
© Frank LaLumia

Anne Adams Robertson Massie
Lynchburg, Virginia
Luncheon in Paris
© Anne Adams Robertson Massie

Eric Michaels
Santa Fe, New Mexico
El Transparente © Eric Michaels

Dean Mitchell
Overland Park, Kansas
James McKinney © Dean Mitchell

Thelma Cornell Spain
Des Plaines, Illinois
Cape Mystic and *Northern Exposure*
© Thelma Cornell Spain

Libby Tolley
Los Osos, California
Autumn Afternoon © Libby Tolley

Glossary

ACID FREE—Said of art paper with a neutral pH of 7. This is ideal because a paper with a neutral pH will withstand yellowing over an extended period of time.

BLEND BRUSH—A brush produced with a blend of natural and synthetic hairs.

BLOSSOMS—*See* Oozels.

COLD-PRESSED PAPER—Watercolor paper with a medium texture. It is a popular choice because it satisfies the widest range of painting styles.

COMPLEMENTARY COLORS—Colors directly opposite each other on the color wheel.

COMPOSITION—Arrangement of forms, lines, values and other pictorial elements into a picture design.

CONTRAST—Differences between values, hues or other design elements.

DECKLE EDGE—The ragged edge on quality watercolor paper.

DESIGN—The planned grouping or arrangement of the elements and details in a composition.

DESIGN ELEMENTS—Line, shape, size, value, color, direction and texture.

DIRECTION—In art, the pattern of movement the eyes follow through a picture. The eye path controlled by careful manipulation of the elements of design.

DRAFTING TAPE—A tape used to block out an area on the paper to get a straight line. It looks like masking tape but is better.

DRYBRUSH—A method of painting with just a little bit of paint or moisture on the brush, creating a "skipped" or "missed" effect. Many artists dip their brushes into the paint, then wipe most of it off with a paper towel. Drybrush lightly across the paper so that only the raised portions get paint.

FEAR—False Evidence Appearing Real.

FERRULE—The metal part of a brush that holds the hairs or bristles.

FILBERT—An oil painting brush with an oval-shaped tip and rough bristles.

FLAT BRUSH—A brush for washes with flat hairs and a long handle, available for use with many painting mediums. Some flat brushes have bevelled handles for scraping designs into your paper.

FLAT WASH OR APPLICATION OF PAINT—A relatively even application of paint that has no significant variations in value or color and no brush marks showing.

FORM—That which unifies an object's structure and outlines to give the appearance of three-dimensional shape.

FRENCH EASEL—A folding, adjustable wooden easel originally made in France, having an attached box for supplies and a place to hold a canvas or watercolor paper.

FRISKET—See masking fluid.

GLAZE—A transparent or translucent layer of color applied over another layer of paint to modify its effect.

GRADED WASH—A painted wash that gradually varies in value from dark to light (or vice versa), or which gradually varies in color from one to another.

GRAYING DOWN—If a color is too bright, add its complement to tone it down.

HARD EDGES—Sharp lines, often defining a form that doesn't blend into adjacent areas.

HOT-PRESSED PAPER—Very smooth watercolor paper.

HUE—The name or classification of a color as red, orange, yellow, green, blue or violet.

INTENSITY OF COLOR—The brightness or saturation of a color. The intensity of a color is the same as its chroma. Watercolor is at its full intensity unmixed with water or another color, straight out of the tube.

KNEADED ERASER—A gray, soft eraser used to lift off pencil marks from the paper.

LIFTING—In watercolor, a term for taking out unwanted pigment using either a dry brush, sponge, tissue, paper towel, finger or cloth.

LIGHTFAST—Colors that are resistant to fading on long exposure to ultraviolet light, particularly sunlight. Many fluorescent lights give off excessive ultraviolet light, and this can cause fading and deterioration as well.

LINE—A continuous mark as made by a pencil, pen or brush in an artwork, as distinguished from shade, color or mass. A set of marks, shapes, colors or other elements that lead the viewer's eye through a work of art.

LIQUID MASK—See masking fluid.

LOCAL COLOR—The identifying color of an object in ordinary daylight. Also the mental identification of a subject's color (grass is green, apples are red, etc.).

MASKING TAPE—Tape used to cover or hide an area of paper the artist intends to remain white, usually for a straight line. Masking tape is not the best to use because it will pull up the paper. See drafting tape or watercolor tape.

MASKING FLUID—A liquid mask, or liquid frisket, that can be removed by rubbing with the fingers and is used to block out areas on paintings in watercolor and other mediums. Colored masking fluid is available for instant recognition of areas covered on artwork. See rubber cement pick-up.

MASS—A sizable area of a composition, as opposed to a line, or the bulk of an object.

MOVEMENT—In painting, the quality of representing or suggesting motion. Movement also refers to the way an artist guides the viewer's eye through the image. For example, the use of bright contrasting colors attracts attention to a subject.

MUD OR MUDDY—Cloudy, dull colors that have lost their brightness, clarity or sparkle, often caused by overworking or mixing too many colors together.

NATURAL HAIR BRUSH—A brush made from animal hairs, such as sable, ox, camel or squirrel, not man-made fibers.

OOZELS—Patterns that appear when one wet color is put next to another wet color. These are also called blossoms. Oozels are not desirable most of the time.

OPAQUE—Watercolors that do not allow light, or the white of the paper, to show through them.

pH—Expresses acidity and alkalinity on a scale from 0 to 14, with 7 being neutral. Numbers less than 7 are more acid, while numbers greater than 7 are more alkaline. Paper with a neutral pH is best because it withstands yellowing over time. Low-quality papers like newspapers have high acidity and discolor rapidly.

PRIMARY COLORS—Red, yellow and blue. Mixing two primary colors together produces a secondary color.

PURE HUE—Watercolor straight from the tube, unmixed with water or another color, at its most intense.

RAG CONTENT—Percentage of cotton fiber in paper. Cotton fibers are stronger than the wood fibers used in less-expensive papers. High rag content means greater strength to withstand the manipulations of various painting techniques, such as stretching watercolor paper, and resistance to deterioration over time. The highest-quality papers are 100 percent rag. Rag content and pH are the major factors determining longevity of paper under normal conditions.

RESIST—A substance (such as masking fluid) that protects a surface from receiving paint.

ROUGH WATERCOLOR PAPER—Paper with a rough surface. Artists whose style makes strong use of textural effects, such as dry-brush techniques, prefer rougher paper surfaces.

ROUND BRUSH—A completely round brush with a pointed end. This is the most commonly used brush among watercolorists.

RUBBER CEMENT PICK-UP—This was designed for erasing excess rubber cement and cleaning areas around glued surfaces. It can also be used to pick up masking fluid.

SATURATION—A color's intensity, or chromatic purity, free from dilution with water or white. Pure hues have the highest saturation of color.

SECONDARY COLORS—Orange, green and violet. The secondary colors are made by mixing two primary colors. These are also called complementary colors.

SHADE—The relative darkness (value) of a color owing to interception of light, as in shadows. Shading may also mean the reproduction of the effect of shade in painting or drawing, or to paint so that shades pass gradually from one to another. The term shade may also mean a color obtained by adding black to a hue.

SHAPE—The visible outline of an object or area in a painting.

SIZE—Relative or proportionate dimension.

SIZING—A gelatin substance used to fill in the pores in paper surfaces, such as watercolor paper, to control the degree of absorbency. Sizing usually occurs during the manufacturing process. Different manufacturers don't use the same amount of sizing on their paper.

SOFT EDGES—These edges define form but have limits without definite lines allowing value or color to blend into adjacent areas.

STUDENT GRADE—Grade of artist's colors and other materials, not of the finest quality.

SYNTHETIC HAIR BRUSH—A brush made from man-made fibers, such as nylon, rather than natural hairs. When budgets do not permit the purchase of quality natural hair brushes, synthetic brushes provide an excellent substitute.

TERTIARY COLORS—Produced by mixing a secondary color with a primary color. There are six tertiary colors.

TEXTURE—In artwork, the visual or tactile characteristics of a surface, such as smooth or rough.

TOOTH—The degree of roughness or smoothness of a paper's surface. The tooth of most watercolor papers is either hot-pressed, cold-pressed or rough.

TRANSPARENT—Watercolors through which you can see the white of the paper or underlying paint layers.

VALUE—The relative lightness or darkness of particular colors in a painting. Generally, high values are light and low values are dark. All colors have value.

WASH—In watercolor, a thin, liquid application of paint. Many artists apply washes with long, broad sweeps of a wash brush to lay down a preliminary ground. A wash applied over another layer of paint is a glaze.

WATERCOLOR BLOCK—Sheets of watercolor paper stacked and bound on all four edges to form a block. You can paint on the top sheet and when dry remove it singly, leaving the next sheet ready for use.

WATERCOLOR PAD—Sheets of watercolor paper bound into tablet form.

WATERCOLOR TAPE—Tape that is made especially for blocking out an area on the paper to get a straight line.

WATER-SOLUBLE—Paints capable of being dissolved or made fluid by mixing with water.

WEIGHT OF WATERCOLOR PAPER—The relative heaviness or thickness that makes a particular paper suitable for a particular use. For example, 90-lb. (190gsm), 140-lb. (300gsm) and 300-lb. (640gsm) indicate weights of papers, and relate to the weight of a ream (five hundred sheets) of a specific sheet size. Heavier paper generally has more strength and stability. It also remains flatter when wet, eliminating the need for stretching.

WET-IN WET—Painting additional color into an already wet area, creating a soft, flowing effect in watercolor.

Index